OVERHEARD

THE ART OF EAVESDROPPING

OSLO DAVIS

hardie grant books

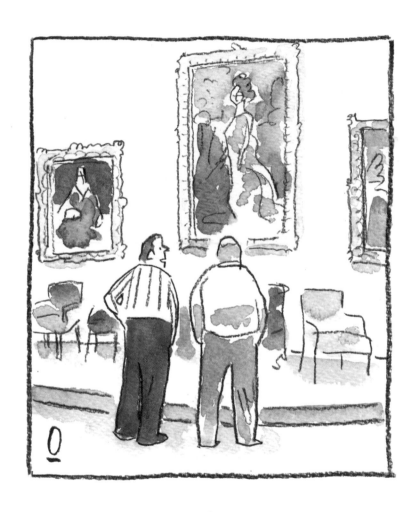

ART GALLERY, WEDNESDAY 3PM

'That reminds me, how's Barbra's shingles?'

CONTENTS

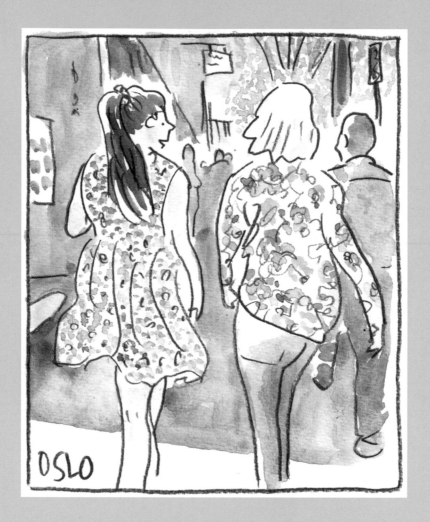

CITY, FRIDAY 1PM

'This is the sort of first world problem I'm talking about:
should I get second world noodles or a third world curry?'

INTRODUCTION

To overhear is human. Don't feel guilty about it. If someone wants to shoot their mouth off in public about their private life, it's not your fault if your ear gets in the way. Overhearing is an accidental, victimless pleasure; a nugget of gossip or snarkiness or exasperation that arrives by happenstance, free of charge.

And if you get away with it, if nobody suspects you overheard, all the better. Someone whines about their terrible wedding, or flirts lasciviously with the waiter, or tries to weasel their way out of a christening and you overhear all about it, no worries: you can't now *unoverhear* it! In fact, you'll most likely enjoy it. Tell your family about it at dinnertime or Tweet it to the world.

For the last decade I've been doing pretty much exactly that. I've been overhearing stuff and then telling the world about it via a single panel cartoon called *Overheard*, which is published every week in a local newspaper. My favourites from more than 500 (including the weird ones, the nonsensical ones, the gobsmacking ones) are presented here in this book.

But to be completely honest with you, *Overheard* is a misnomer. What I've actually been doing is *eavesdropping*, overhearing's creepier cousin. Eavesdropping is the accidentally-on-purpose overhearing that one elects to engage in, that one hunts and gathers. ('Eavesdropping' comes from the act of lurking outside under a house's eaves, undeterred by the drops of rain falling on you as you stubbornly focus your senses on hearing what's going on inside.)

In the pursuit of an overheard I have made it my business to get good at strategically positioning myself, stalking people for a couple of blocks, checking my watch as if I'm waiting for someone, keeping my headphones on but turning the sound down. The techniques vary, but the goal is always the same: catch a believe-it-or-not, swear-to-god-it's-true quote uttered by someone I've never met before in my life.

I justify this creepiness by saying I'm simply fulfilling journalistic duty, bringing overheard sugar to the masses. But it's become more than that. It's now kind of an addiction, an affliction and, at times, a curse. I hear voices all the time. I'll put my hand up a bit to stop my kids from talking so I can tune into the conversation at the next table. My eavesdropping radar is always set to 'sensitive'. I'll hang around cinema queues on cheap Tuesday nights, mooch near the popular paintings in art galleries, make myself inconspicuous down the other end of a park bench. I'll fake-read the backs of books in the self-help section of a bookshop. I've become skilled at loitering with intent, the intent of bagging a big, juicy, fully formed overheard.

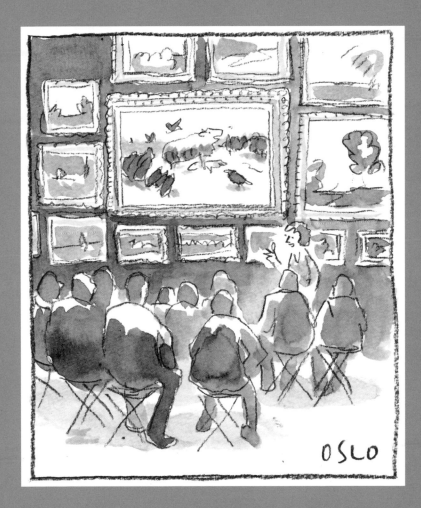

ART GALLERY, WEDNESDAY 10:45AM
'Look closely at the sheep's face: such expression.
Kind of like an expression you might see in *Shrek*.'

SHOPPING CENTRE, FRIDAY 3PM

'Everyone there said I looked thinner – which means I'm remembered as fat.'

The best overheards are of course the ones that force you to creep into the danger zone: close enough to hear, far enough away to be unnoticeable, vague, opaque. Annoyingly, the volume of a stranger's voice is inversely proportional to the juiciness of what's being said. And if they sense an interloper they'll shut down completely. People have an amazing awareness of the auditory bubble their voices occupy, and have alarms that trigger when that bubble is breached.

And it is I who must weasel into these danger zones and nick the tastiest morsels. (People talk in big paragraphs, but my cartoon space has a word limit, so I must extract the best sentence.) Eventually, after floating around the women's jeans section of a department store pretending to shop for a pair of women's jeans, for example, I will hear what I need to hear and get the hell out of there. I don't hang around. I slip away, dissolve back into the crowd, sometimes pausing at a safe distance to take a sneaky photo that will assist in the drawing later on. Some days I will return home with five or six useable overheards. Other days nothing.

Popular culture tells us there are consequences for eavesdropping. As a plot point in novels (think Jane Austen), Shakespeare (*Much Ado About Nothing*) and movies (*Goonies*), eavesdropping ranges from the convenient to the absurd, but it's a device that resonates. What if we overheard a lie, an affair, something to do with murder? What do we do with this information? How do we release the burden of this unsanctioned knowing? At what point is overhearing too much information?

And what if I get caught? It hasn't happened yet, but imagine if it did: how embarrassing! How on earth would I explain myself?

Ten years in the business has given me time to reflect on all this. I've learned how a wry comment, a snarky aside, a witty retort or a bruising rejoinder can reveal a deeper humanness in a stranger I would not normally think twice about. The little stuff people say speaks volumes. A couple's prickly relationship can be summarised in a quick quip, an unusual turn of phrase or an odd selection of adjectives.

It's this brevity that makes overhearing tantalising. We are allotted just a couple of pieces of the jigsaw puzzle and so must imagine the rest. Who *are* these people? Who's on the other end of the phone call? His mum? His wife? Or lover? We think we have a pretty good idea who, but that all goes out the window when he utters a few particular words during his goodbyes (unexpectedly saccharin, or curt words, for example) and we have to rethink the whole conversation.

CITY, TUESDAY MIDDAY

'I was driving past. You were out the front wearing a grey jumper, digging.
I had my hand on the horn but Sam said it was too late to beep ... About 1, 2am.'

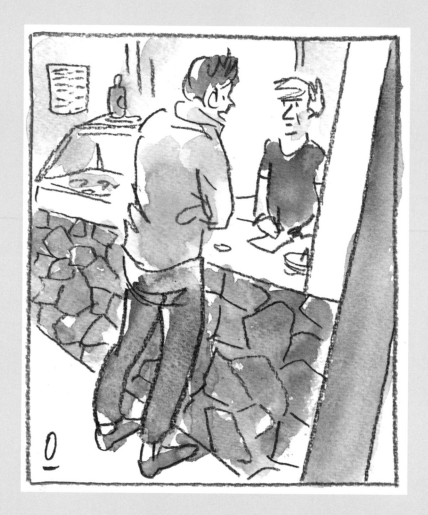

TAKEAWAY SHOP, SATURDAY 7PM

'Hang on – satay's, like, got a shitload of peanuts in it, hasn't it?
Or is it chickpeas? Cause I can't eat peanuts. And I don't like chickpeas.'

Despite the snarkiness in many of these overheards I can't help being very pleased with the wit and humour you guys have. You kill me, no seriously you do. It's been an honour getting to know you. So please keep it up. Yack away in public, rabbit on, let something slip, use your inside voice outside, don't hold back. It's not your fault if somebody's ears get in the way.

Oslo Davis is an illustrator, artist and cartoonist whose work appears in newspapers, magazines and various other media worldwide. His weekly cartoon *Overheard* has been published in *The Age* newspaper since 2007.

FAMILY MATTERS

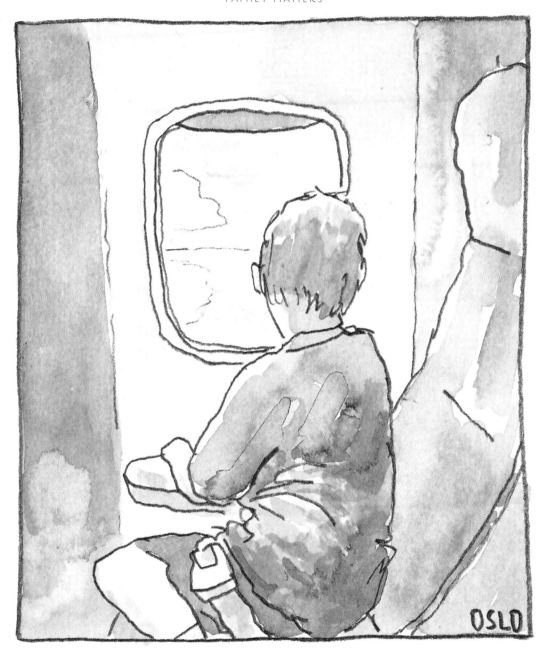

ON A PLANE, MONDAY 3PM
'Wow – Mum, look! It's just like Google Earth!'

THE BEACH, TUESDAY 1PM

'Let's not pick the kids up from school and see what happens.'

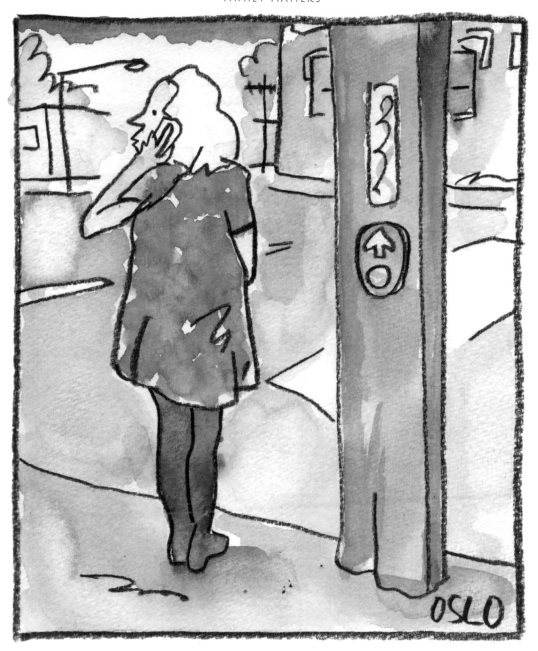

SUBURBAN STREET, WEDNESDAY 5PM

'Good girl. Excellent! No shoplifting.'

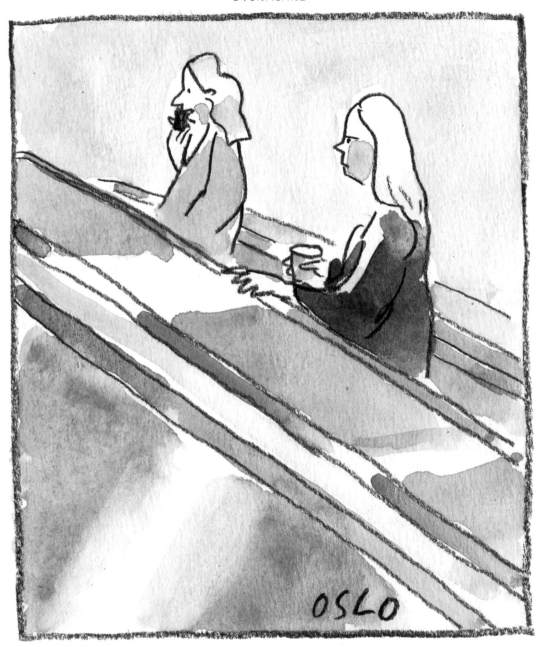

TRAIN STATION, MONDAY 8AM

'What do you mean she's got nits again?! Just eggs or full-blown nits? We both slept in the tent!'

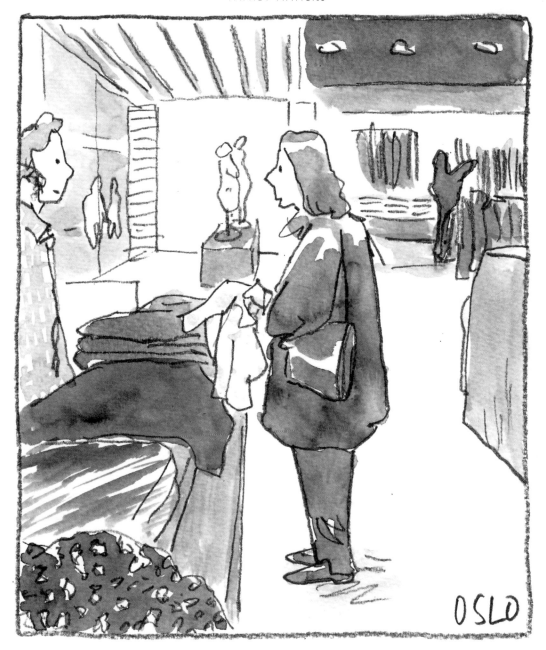

MEN'S CLOTHES SHOP, THURSDAY 1PM

'Just need to return this. My husband's "slim fit" days are long gone.'

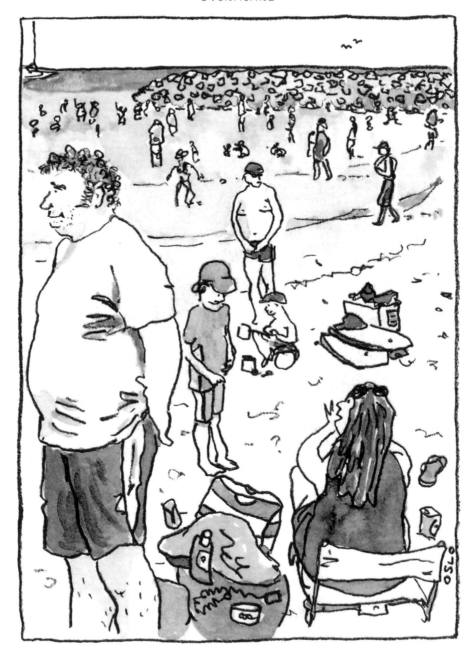

THE BEACH, SATURDAY 1:30PM

'Are you "swimming" swimming? That just looked like walking around. Except in water.'

COUNTRY TOWN, SATURDAY 11AM
'Poppy's gone back to get his special little bag. He thinks he left it by the basin in the loos.'

CITY, THURSDAY 6:30PM

'Well, dry retching usually means something's not right. Was he watching *Jersey Shore*?'

CHILDREN'S FARM, FRIDAY 11AM
Her: 'I don't want to go near chickens ever again!'
Him: 'It's ok, it was just a little peck. Hardly bird flu … How's your temperature?'

PARK, SATURDAY 2PM

'No, Mum, you can't invite more people. There aren't enough seats, understand?
Lynn's managing this. But that's another issue altogether and we're not going to go there, ok, Mum?'

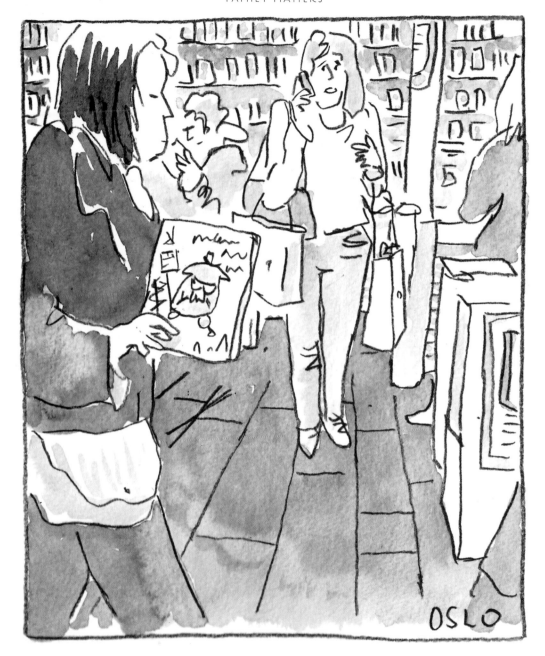

BOOKSHOP, SUNDAY 11AM

'I'm going to have to cut you off, Mum – this is just a shopping call. I'm in a frenzy!'

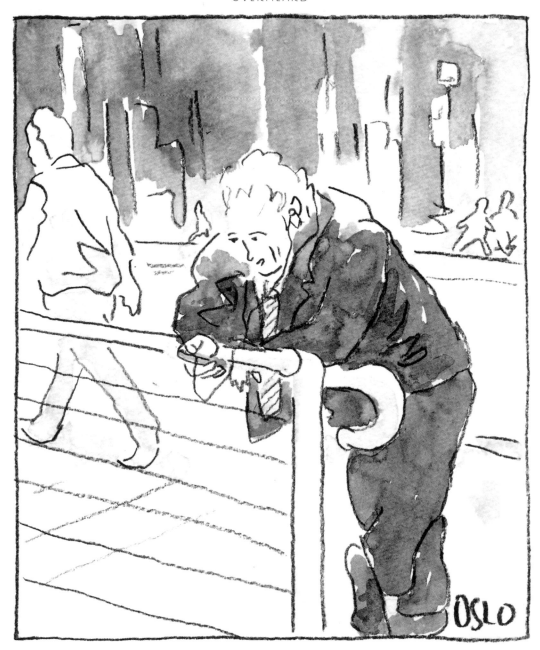

CITY, WEDNESDAY 3PM

'Well, my mum said her life was ruined the day I learned to talk and put sentences together.'

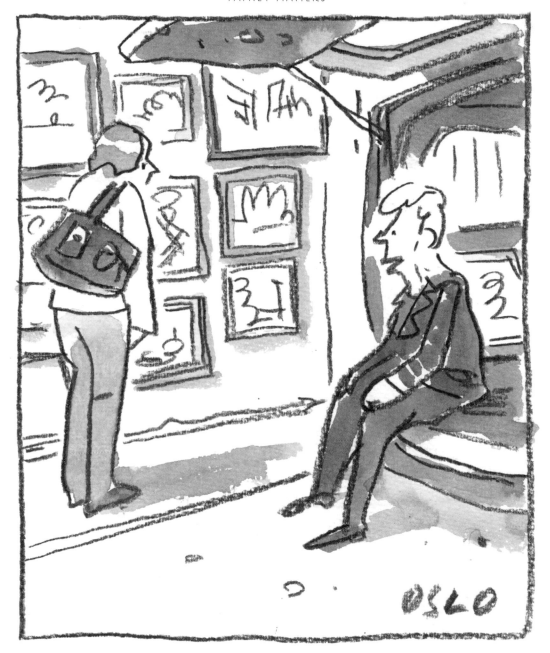

WEEKEND MARKET, SUNDAY 10AM

'The one next to it is an original. That's one of my wife's signature dolphins.'

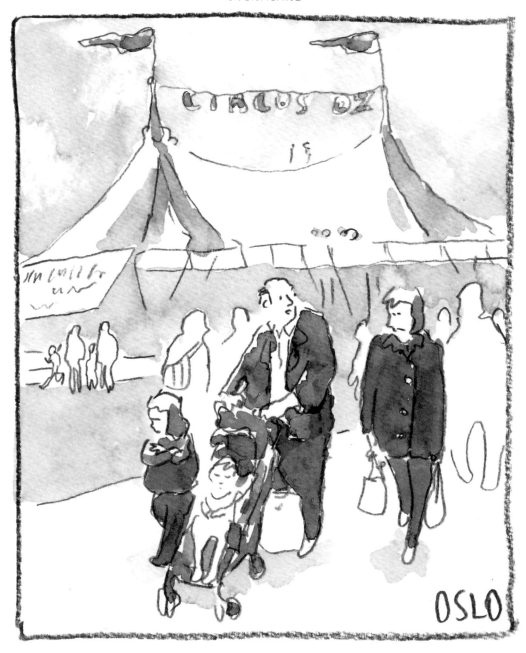

OUTSIDE A CIRCUS TENT, SUNDAY 3:30PM

'It was game over when she realised there'd be no monkeys.'

SUBURBAN SHOPPING STRIP, FRIDAY 11AM

'If Santa brings the kids craft then I end up making craft, and I hate craft.'

FARMERS' MARKET, SATURDAY MIDDAY

'My son was on the trampoline with all the girls and they were screaming and running away from him because they said he was Trump and he was going to grope them!'

FOOTBALL FIELD, SUNDAY 10:30AM
'Sienna! Sienna! SIENNAAAA!!! GET BACK!!!!! No, no, run out THERE!!!
WHAT ARE YOU THINKING???!!!!'

MODERN LIFE

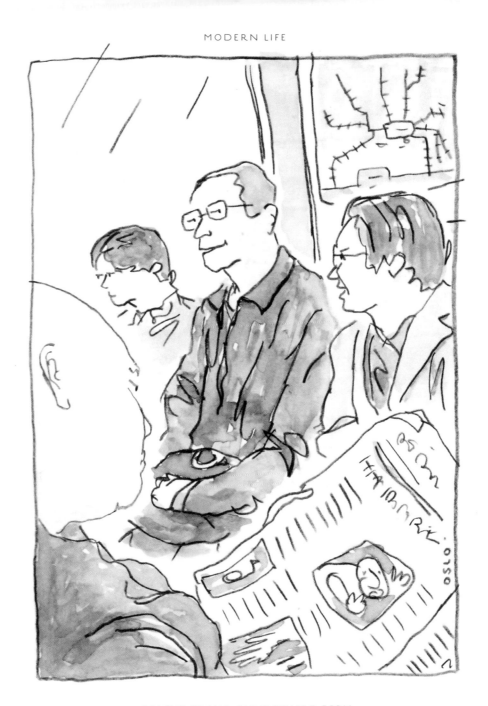

ON THE TRAIN, THURSDAY 5:55PM

'In that song, they never found out "Who Let the Dogs Out?", did they?'

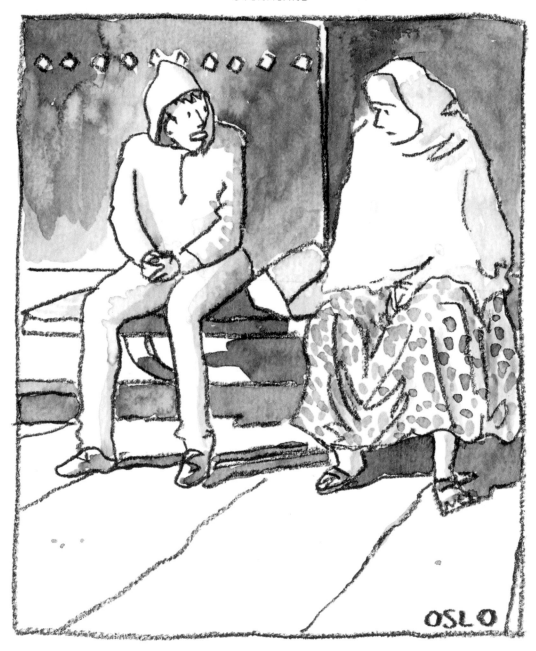

BUS STOP, FRIDAY 6PM

'My hoodie's my burqa.'

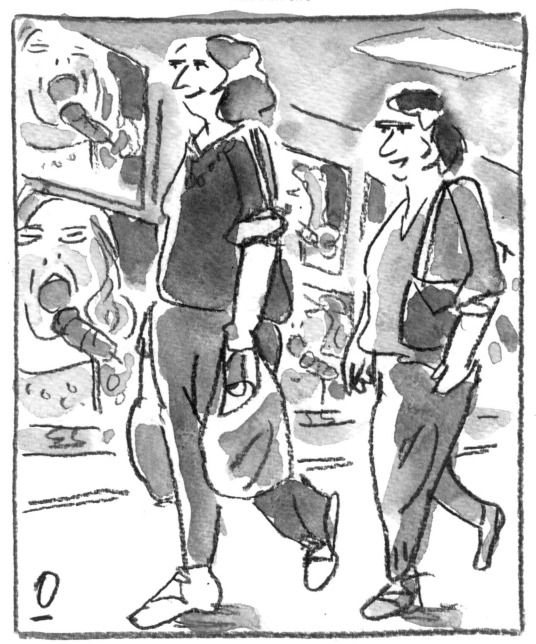

ELECTRONICS SHOP, FRIDAY 2PM
(In a deadpan voice) 'Sing it, Adele. Sing it.'

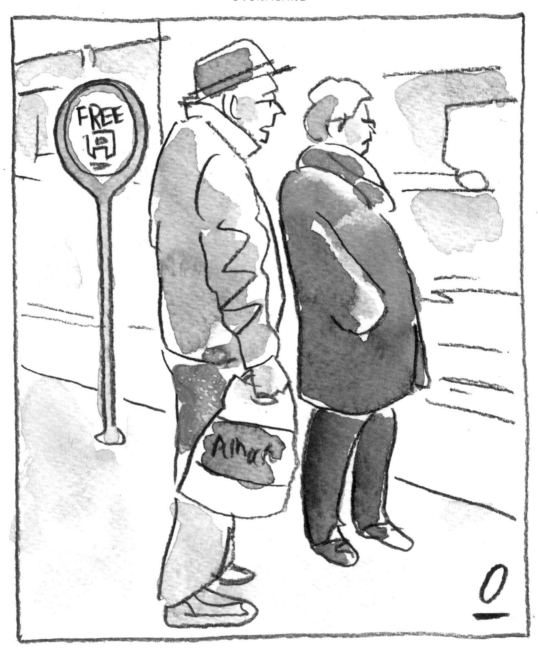

TOURIST SHUTTLE BUS STOP, FRIDAY 11AM

'Just because it's free doesn't mean it can be late.'

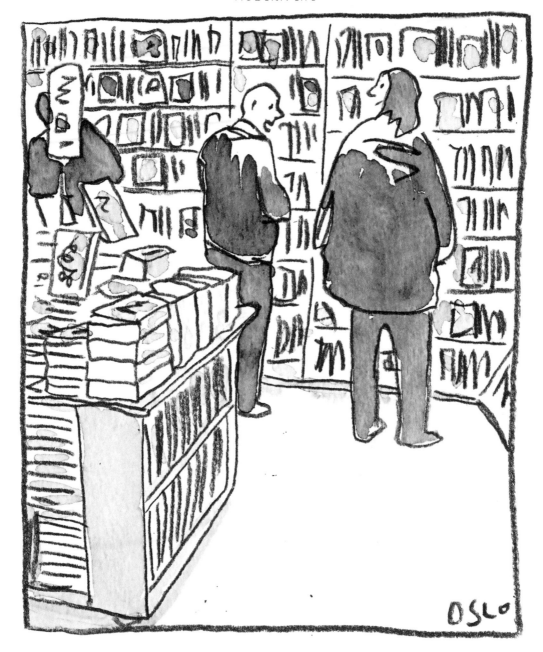

BOOKSHOP, TUESDAY 4PM
'They've put *On Death and Dying* in the self-help section.'

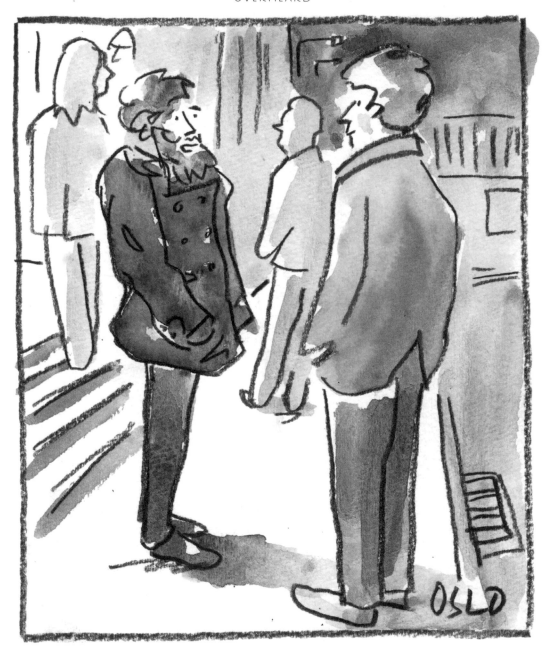

CITY, SATURDAY 7PM

'I took what Kraftwork were doing but gave it an edge. I put it in its rightful home: jazz-funk!'

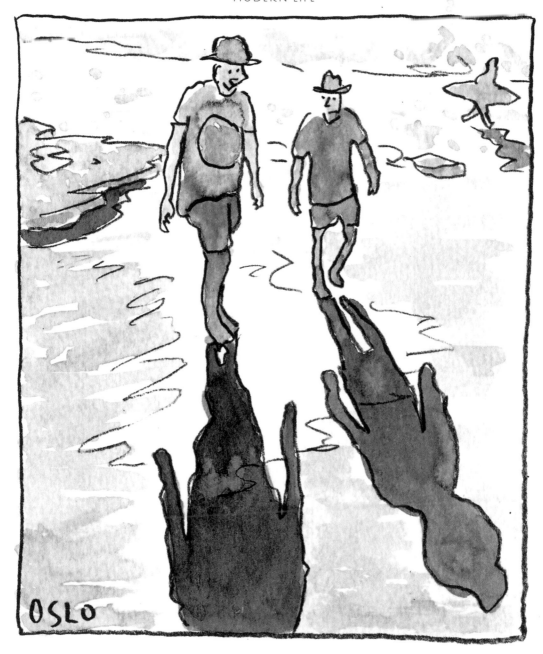

THE BEACH, SATURDAY 9:30AM

Man One: 'Did you hear how I was nearly hit by an LFP?'
Man Two: 'An LFP?' Man One: 'A Low Flying Pigeon.'

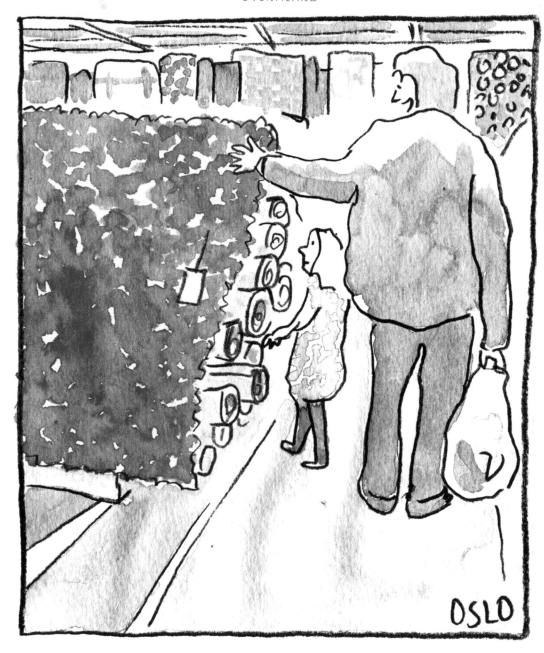

RUGS DEPARTMENT, IKEA, SUNDAY 11AM

'And this one's 100% pure Elmo!'

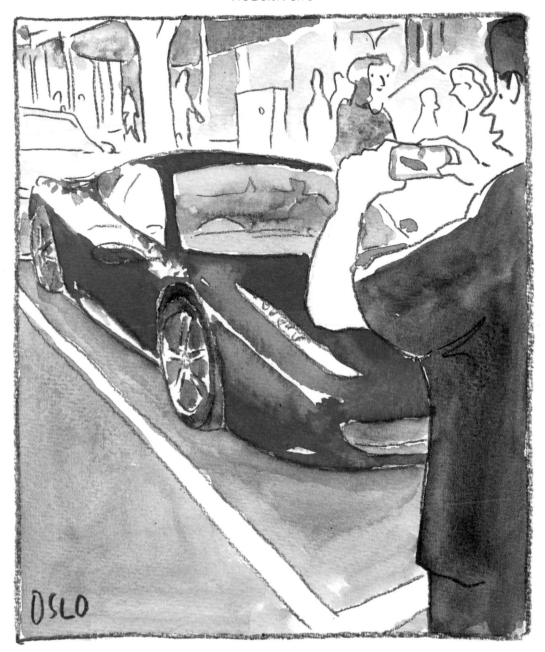

CAFE DISTRICT, SUNDAY MIDDAY

'Act ludicrously rich.'

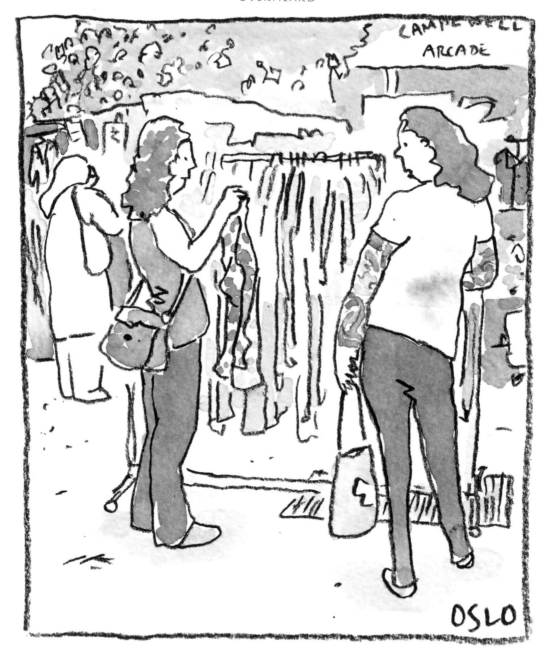

OUTDOOR MARKET, SUNDAY 10:30AM

'You cleanskins are so hot right now.'

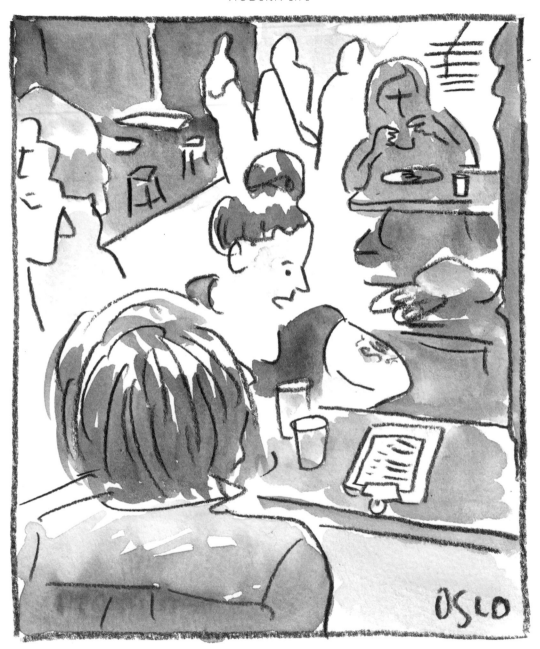

ARTS PRECINCT, FRIDAY 1PM

'He did a pretty good job, but the "W" looks like it's back to front ... '

OUTSIDE A MUSEUM, FRIDAY 5PM

'I'm so stressed! I've been EVERYWHERE for yoga mats!'

TRAIN STATION, TUESDAY 2PM

'I thought you might like to join me … Any time's good … Oh, really?
Well I can come to you? … Ah well, let me give you a virtual hug.'

SUBWAY WALL ART, FRIDAY 2PM

'It's terrible! I love it! ... Hang on, is it just about recycling?'

ART GALLERY, SUNDAY 3PM

'I think I'm getting it now. I read up on it. I wasn't sure, but now I am.
Really getting it. It's all about nostalgia, I think.'

HIGH-END SHOPPING DISTRICT, SUNDAY 1PM

'Well, I'm not going inside. The AC's on and I've just had my hair done.'

BOTANIC GARDENS, THURSDAY 1PM

'Policy areas … Cluster the stakeholders … Devolve the divisions … Workforce capacity …
Build an assessment platform … Key deliverables … Hand it over to expert reference groups …'

IKEA, SUNDAY MIDDAY

'I keep thinking we're over at Adam and Jacinta's.'

INNER CITY, SATURDAY 11AM

'Hipsterdom is quite dead. Now what?'

A BOOKSHOP, FRIDAY 5PM

'Oh this is Jung! This guy is cool! This chapter's called "Introverts and extroverts and the collective unconscious". Right up your alley!'

SUBURBAN STREET, MONDAY 8:30AM

'Nice suitcase, hipster. Looks convenient.'

CITY SHOPPING CENTRE, FRIDAY MIDDAY

'I don't think they're Christians, but they're just as annoying.'

CAFE, SUNDAY 11AM

'What's chambray even mean? Is it like Mexican for businessman or something?'

ART GALLERY, SUNDAY 3PM

'I prefer contemporary art when it's not so popular.'

SHOPPING COMPLEX, SUNDAY 1PM

'What do you mean "Who's Paul McCartney?" He's only Stella McCartney's dad!'

AIRPORT, SUNDAY 2PM
'Oh My GOD! My bag! My UNDIES!'

INNER-CITY CAFE, SATURDAY 1PM

'My film is about a guy who gets dumped by his girlfriend and then sits on the train
listening to a mother talk to her handicapped son. It's kind of like *Before Sunset*.'

CITY CAFE LANEWAY, TUESDAY 4PM

'I'm a more nuanced vegan than you are – I can't even eat in the city.'

CITY, FRIDAY 6:30PM

'She'd hired these shitty little wine glasses. Total cheapskate.
It would have been classier to drink straight from the bottle.'

CITY, THURSDAY 2PM

'It's not about the number of Likes, it's about the *quality* of Likes.'

CAFE, FRIDAY 8AM

'I once saw a cyclist on the footpath run into one of those charity muggers.
I didn't know who not to help.'

COUNTRY TOWN, SATURDAY 1PM

'Quick. My thermal underwear is losing its will to live.'

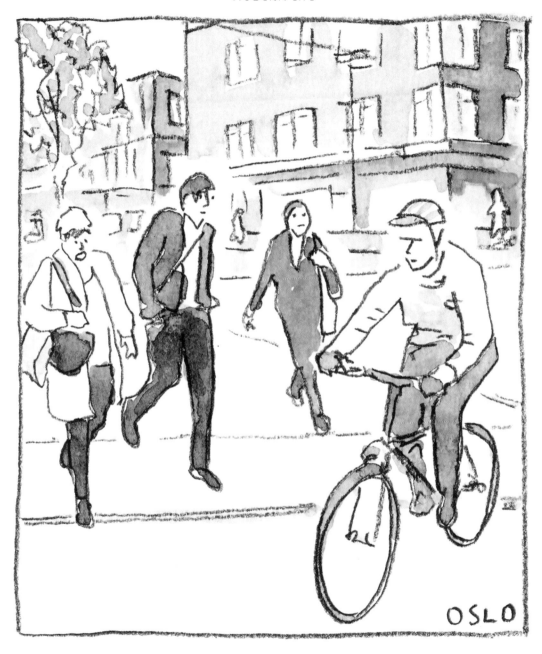

CITY STREET CORNER, TUESDAY MIDDAY

'If I didn't ride to work myself I'd hate these guys.'

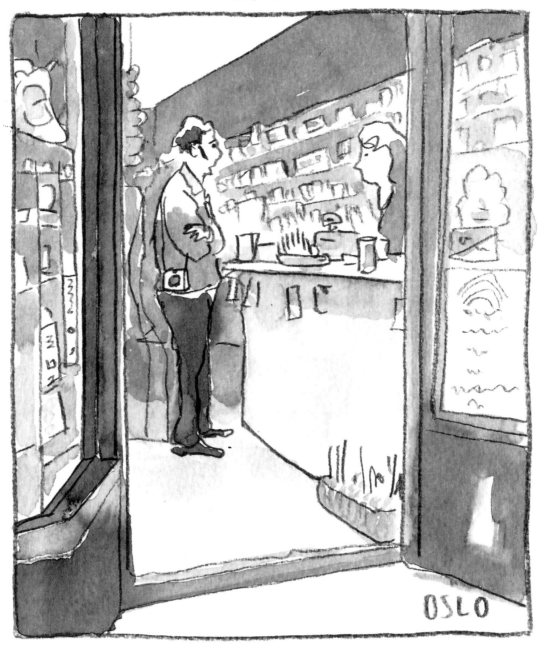

HEALTH FOOD SHOP, TUESDAY 1PM

'If I drink the raw cow's milk you sell, will I die?'

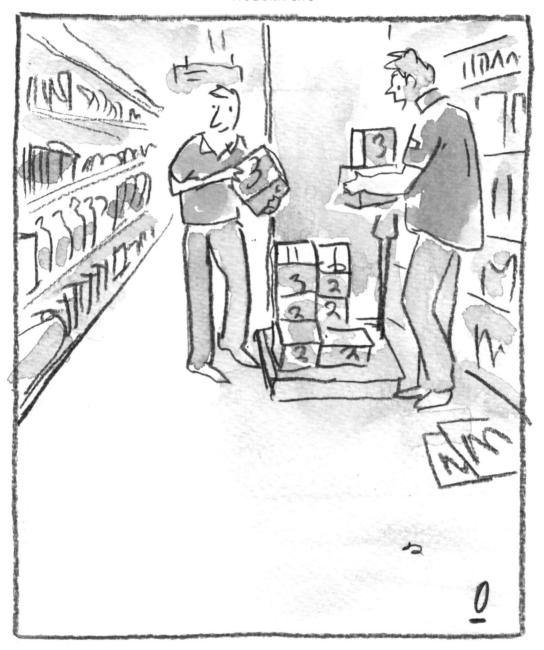

SUBURBAN SUPERMARKET, SUNDAY 3PM

'I can't believe you literally read books! Like, look at the words and turn the pages!'

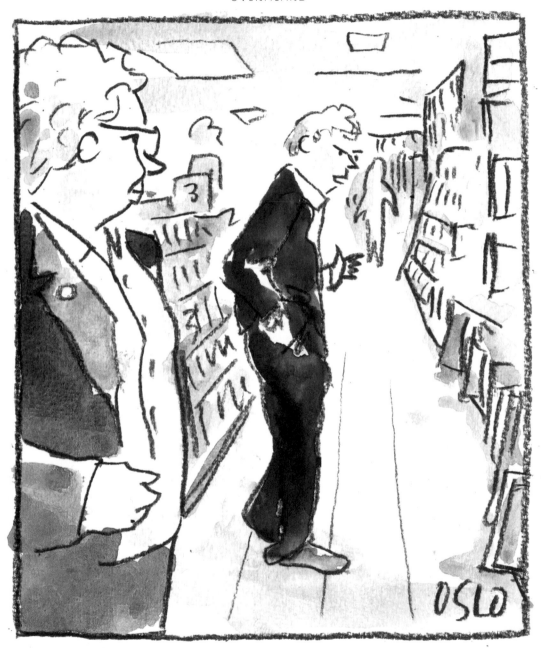

BOOKSHOP, THURSDAY 7PM

'Vague and full of waffle. Evokes such nasty overtones. Utterly unreadable! Can't believe he gets away with it. And I hate the way he talks AT people. Mind you, he could always put me down better than I could put him down.'

CITY NEWSAGENT, FRIDAY 2PM

Shop assistant: 'I hate to tell you this but you've selected the most expensive card in the shop. It's $13.50!'
Customer: 'Gawd – that's more than my present!'

CITY, 2PM MONDAY
'It's Costco, Janice: the wedding gift superstore!'

FOOD TRUCK, SATURDAY 6:30PM

Her: 'How hot is hot?' Him: 'It's hot but not hot hot.'
Her: 'So, it's like, not hot hot hot?' Him: 'Yeah, something like that.'

CITY, FRIDAY 7:30PM

'How much of a loser are you if you have to be in a bookshop at seven thirty on a Friday night!'

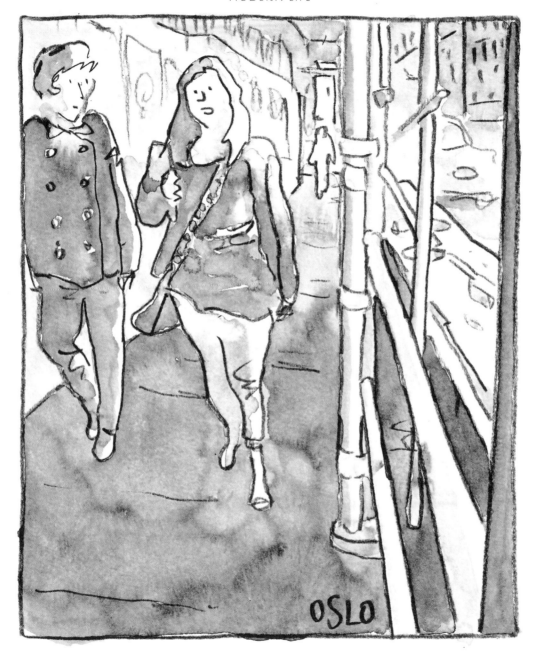

CITY, TUESDAY 2PM

'If the barista has a full sleeve tat, I just feel far more confident the coffee will be good.'

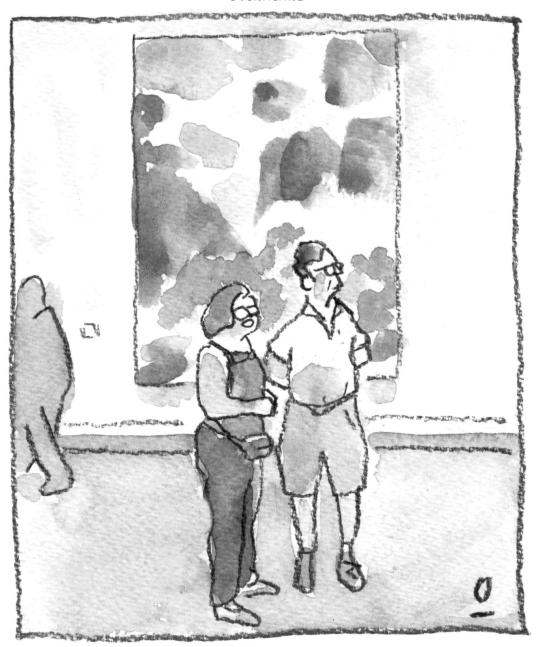

DAVID HOCKNEY EXHIBITION, GALLERY, TUESDAY 11AM
'That one almost makes me want to vomit.'

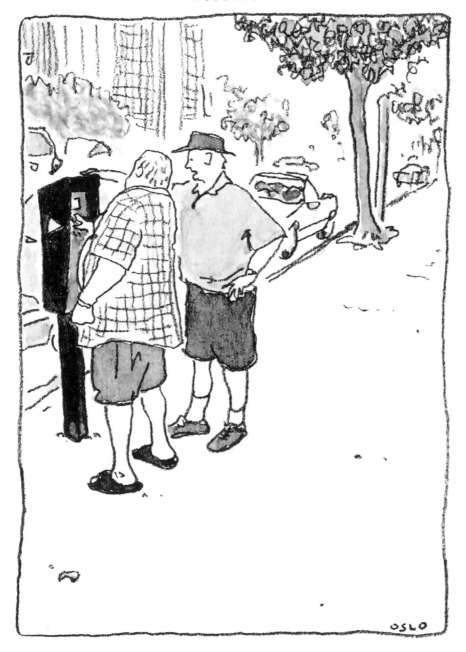

INNER CITY, TUESDAY 3PM
'What's that button do? Defrost mince?'

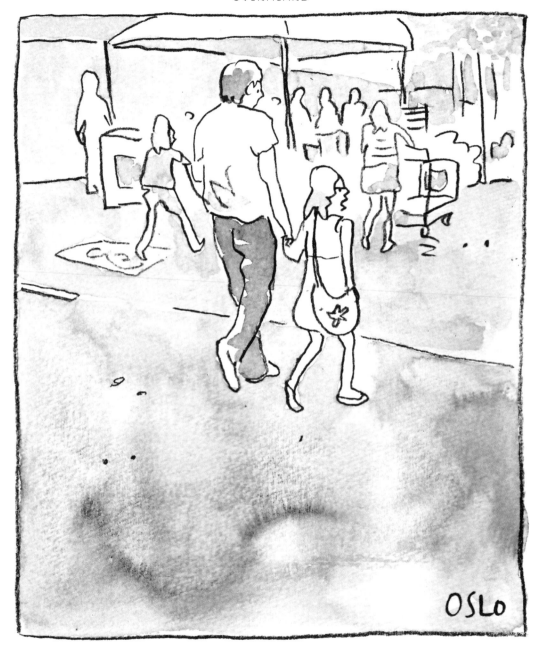

SUBURBAN SHOPPING CENTRE, SATURDAY 3PM
'I could sure use a wheelchair right now.'

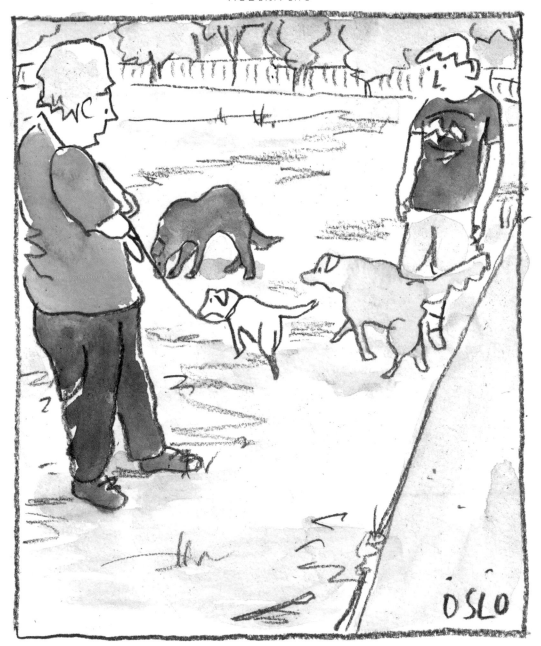

DOG PARK, SATURDAY 11AM

'No Brandus, you can't play with these dogs. You'll kill them, won't you.
Seriously, he'll literally kill them.'

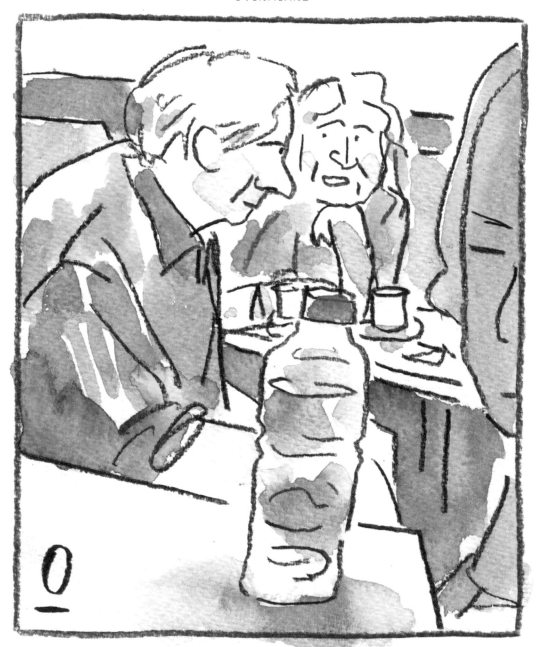

ITALIAN CAFE, SUNDAY 2PM

'Simon reserved some books for me. Mostly socialist stuff. Trotsky. Should make for a fun beach read.'

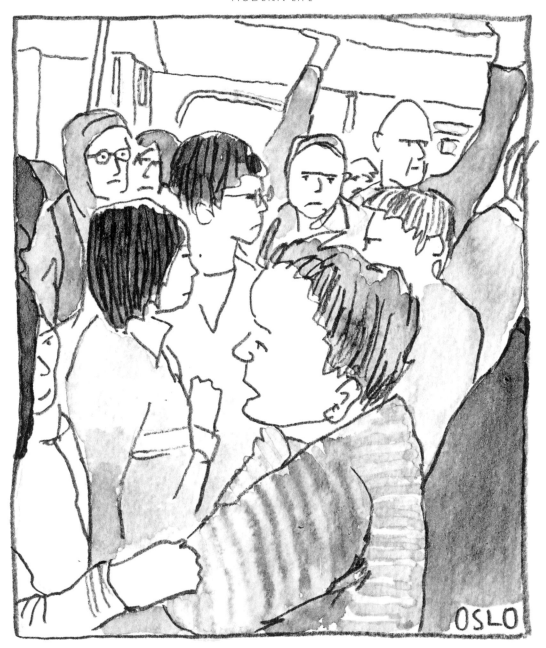

ON THE TRAIN, MONDAY 5:15PM

'I can't tell if that's my phone vibrating or someone else's.'

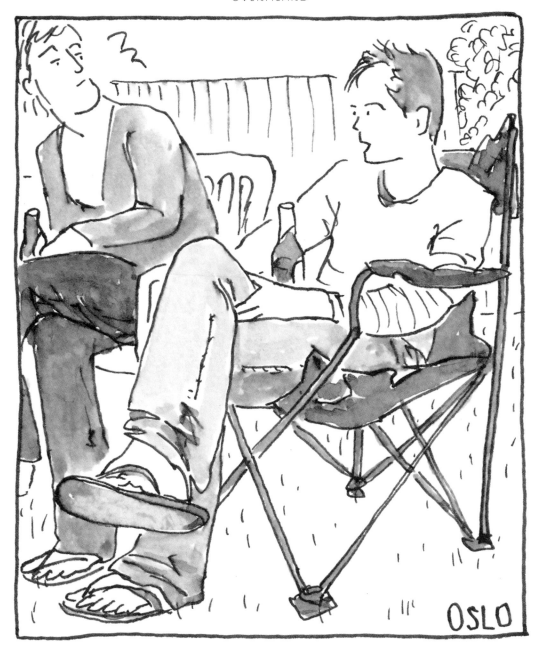

AT A BBQ, SATURDAY

'My pilates teacher and my yoga instructor both hate each other.'

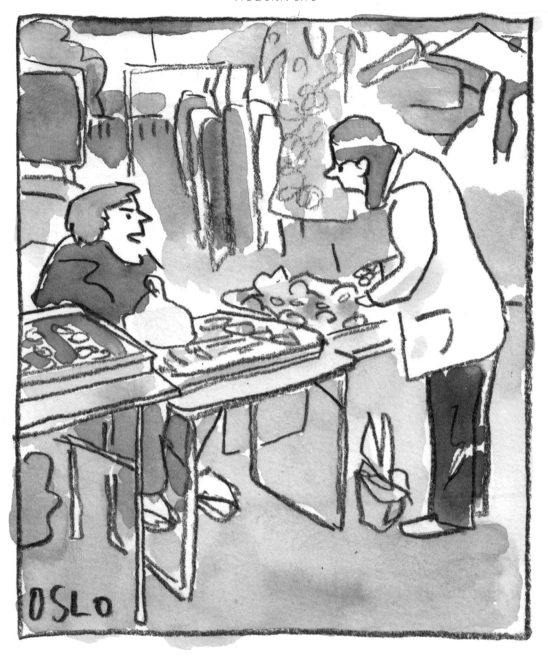

VINTAGE MARKET, SUNDAY 11AM

'Why don't you go away, have a think and then ask yourself:
how much am I willing to pay for a fried egg necklace?'

RELATIONSHIPS

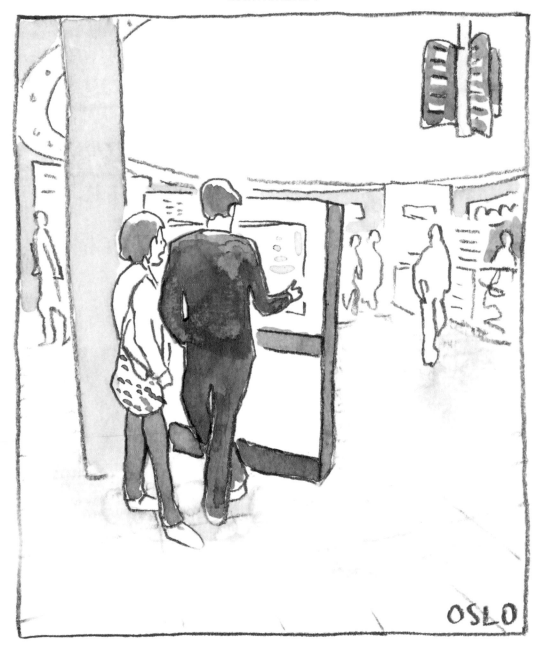

SHOPPING CENTRE, SUNDAY 2:30PM

'See if we can find something else to disagree about.'

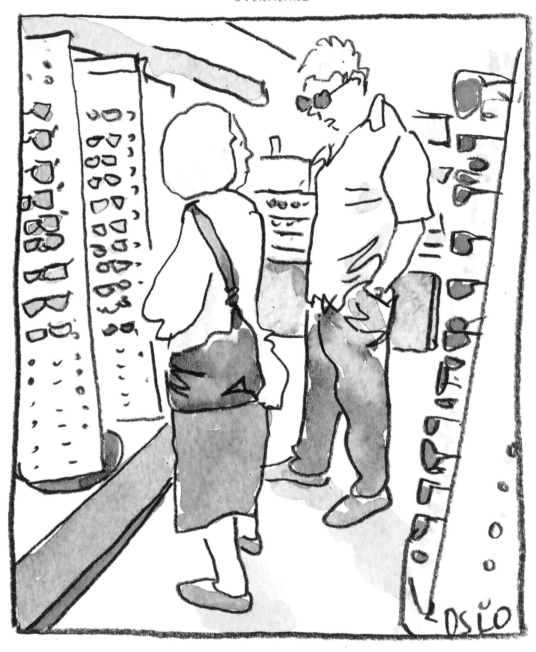

CITY SHOPPING CENTRE, FRIDAY 11AM
'What makes you think I want to look like Rock Hudson?'

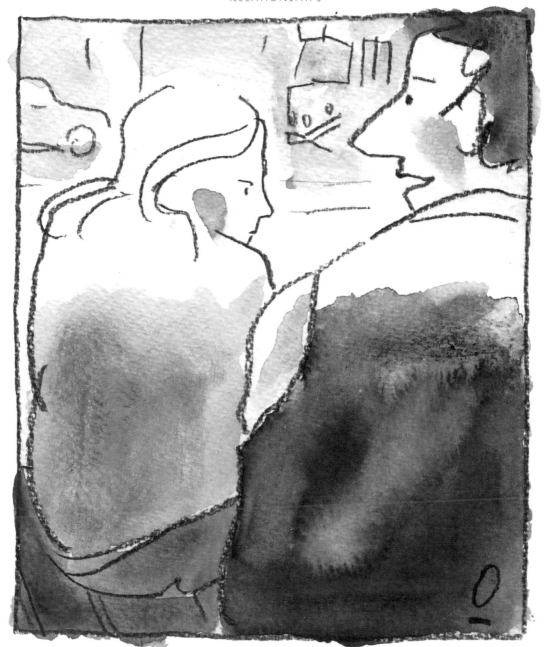

INNER-CITY SUBURB, SUNDAY 2PM

'Well, I'm sorry, but I never claimed to have a black belt in emotions.'

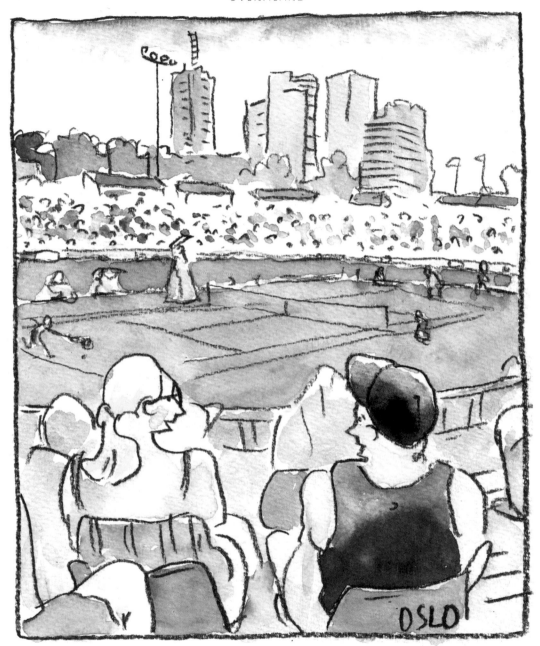

AUSTRALIAN OPEN, SUNDAY 1PM

Her: 'You planning on yelling anything out today, like "Yeah!" or "C'mon!"?'
Him: 'I might do a "Woo!" later.'

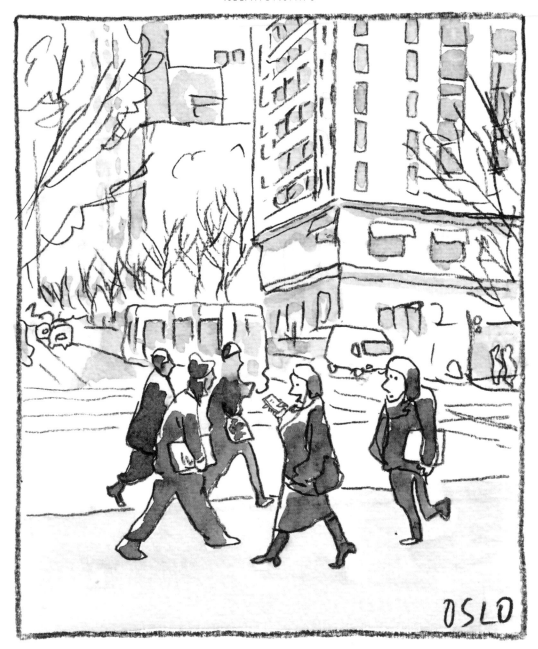

CITY, MONDAY 10AM

'I'm done with his Twitter love. I want his real love.'

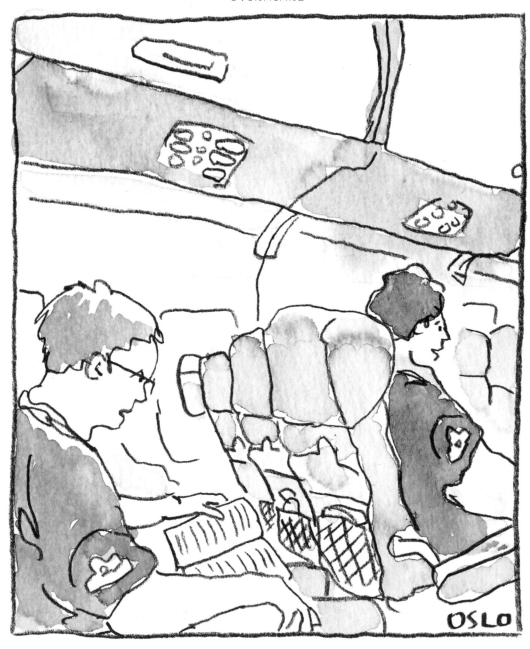

ON A PLANE, TUESDAY 8:30AM

'Recline at your peril, Steve.'

PARK, SATURDAY 11AM

'Don't take it personally – I have literally only five facial expressions.'

ICE-SKATING RINK, FRIDAY 8PM

'The last thing you need on a first date is sliced-off fingers.'

PARK, THURSDAY 6PM

'Last one back goes with my wife to André Rieu.'

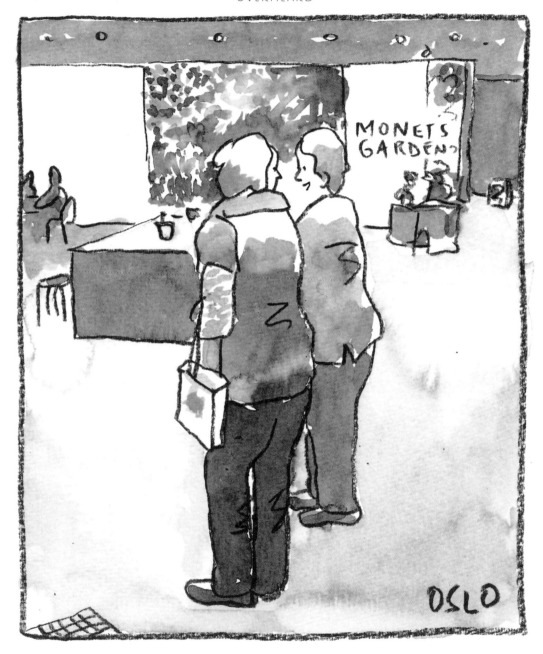

ART GALLERY, FRIDAY 1PM

'It was the most self-indulgent, comatosing, chill-out holiday I ever had.
Like nothing I ever did with Murray, god rest his soul.'

HARBOUR PROMENADE, TUESDAY MIDDAY

Her: 'Were you even listening to what I said?'
Him: 'No, but I know what you're thinking.'

CITY, MONDAY 4PM

Him: 'What I'm most worried about is that they'll think I'm more useful, smarter, that I have more to contribute.' Her: 'Don't worry. They won't.'

CITY STREET CORNER, THURSDAY 2PM

'Hi, Steph. It's me. Just checking my phone is working. It is. Miss you, bye.'

TRAIN STATION, MONDAY 4PM
'Oh my GOD – I've just been to a clairvoyant! I'M GETTING MARRIED!'

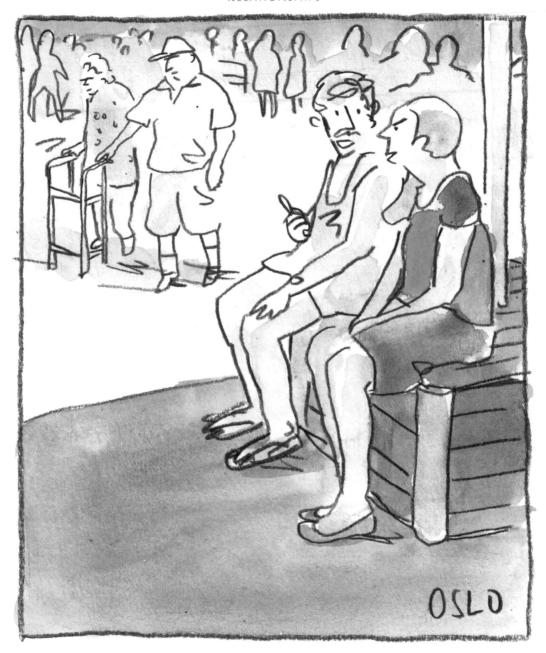

AUSTRALIAN OPEN, TUESDAY 1PM

Him: 'That'll be us in forty years. I'll be like, "Ange, get me a beer!"'
Her: 'And I'll still be like, "Nah, fuck off!"'

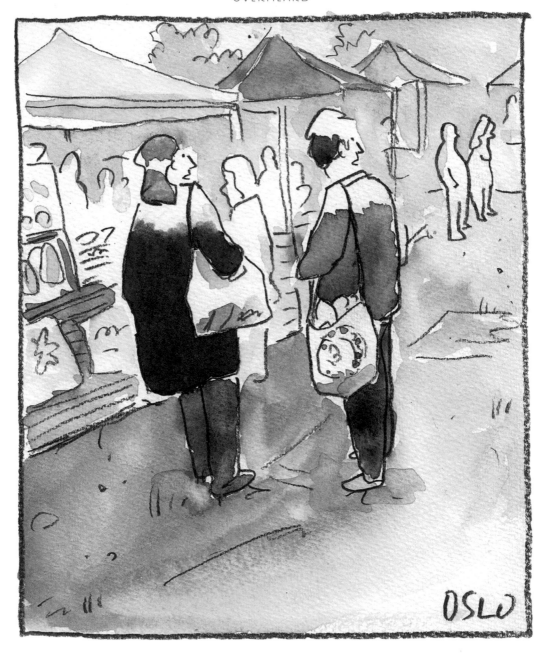

FARMERS' MARKET, 11AM SUNDAY

Her: 'How awful. I would never have chosen that dress.'
Him: 'I would never have chosen that wife.'

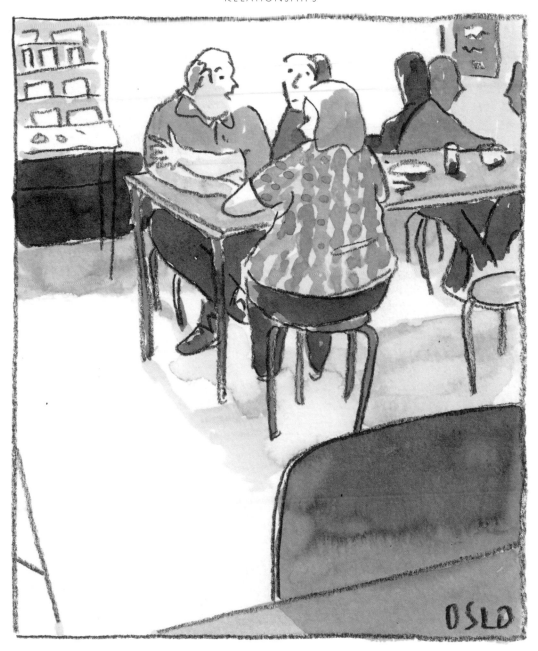

OUTER SUBURB, SUNDAY 11AM

'In the last two months we've both broken two dining chairs, a deck chair and a camping chair.
So much for the Pritikin diet!'

THE
DAILY GRIND

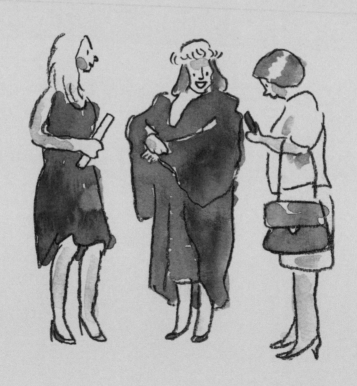

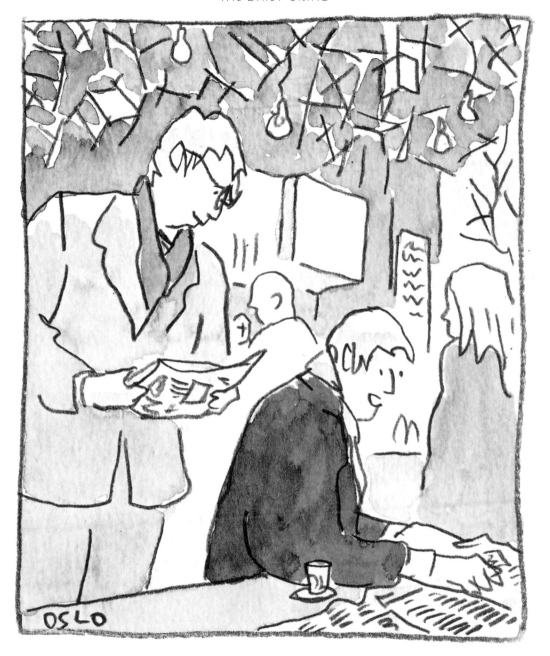

CITY CAFE, THURSDAY 8:30AM

'She's not my best friend now, not by any stretch of the imagination.
She moved desks and said she prefers to sit next to the printer.'

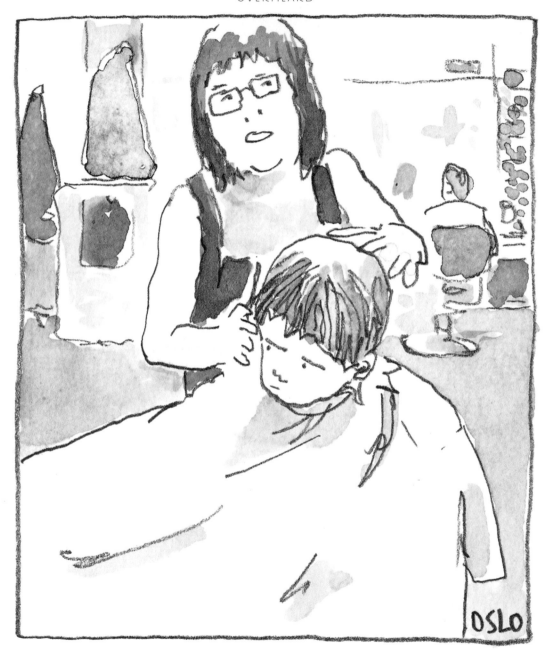

SHOPPING COMPLEX, SATURDAY 2PM

'I'm really good with the customers though. I'm really apathetic towards them.'

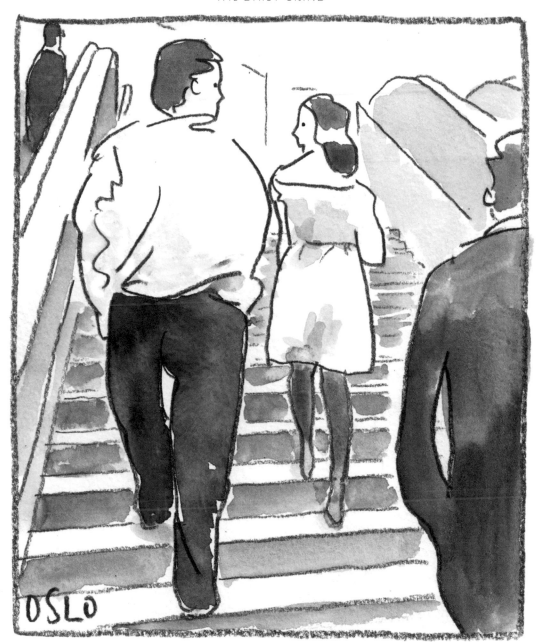

SHOPPING AND OFFICE COMPLEX, CITY, THURSDAY 1PM

'To get the door opened you should smash Sam's nose into it so it becomes a safety issue.'

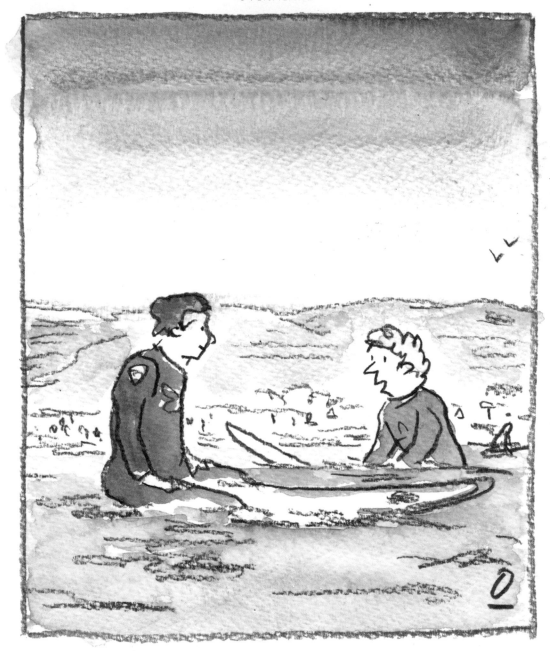

THE BEACH, SUNDAY 11AM

'This week was the grade 5/6 camp in the alps. 18k hike, all uphill.
Lots of crying, but we got them there.'

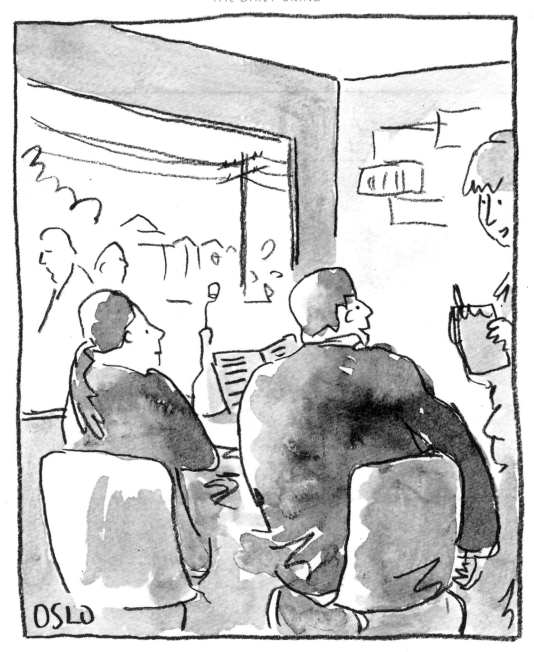

SUBURBAN CAFE, THURSDAY MIDDAY

Customer: 'I'll have the gnocchi.'
Waiter: 'We have gnocchi?'

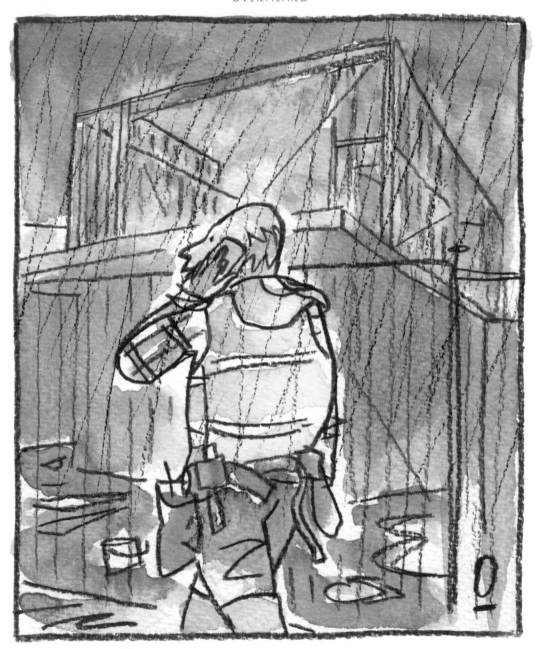

CONSTRUCTION SITE, MONDAY 2PM

'Yeah, mate, 'course we got the roof on. Why you ask?'

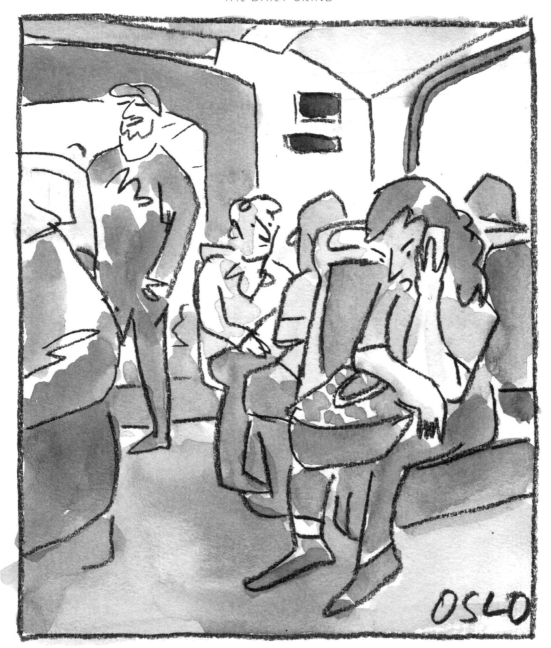

ON THE TRAIN, TUESDAY 6PM

'They said as a general rule they don't support napping at my desk. What's with that?!'

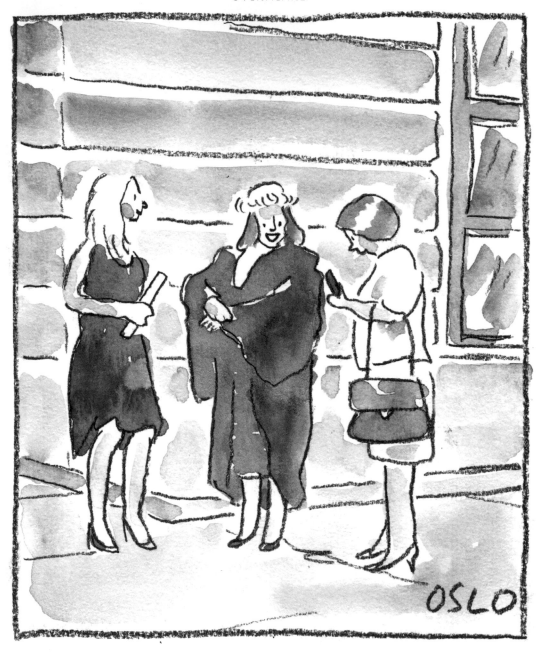

SUPREME COURT, TUESDAY 10:30AM

'They're big sleeves. I feel like I'm Julio Iglesias.'

ON THE TRAIN, WEDNESDAY 8:15AM

'If I do this right, and I'm focused, there's no doubt I'll get my old prison job back.'

FRIENDS
LIKE THESE

SHOPPING DISTRICT, INNER CITY, WEDNESDAY 6:30PM
'Really?! Thanks. 'Cos when I left the house, Emma said I looked like a crack-whore.'

CITY, WEDNESDAY 7PM

First woman: 'Was she drunk?'
Second woman: 'No, she was being a creative writer!'

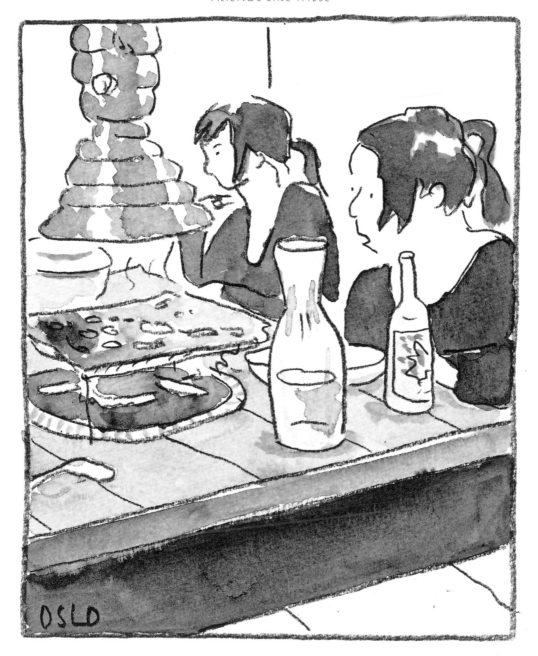

KOREAN RESTAURANT, SATURDAY 7PM

'You have to work hard not to be hated.'

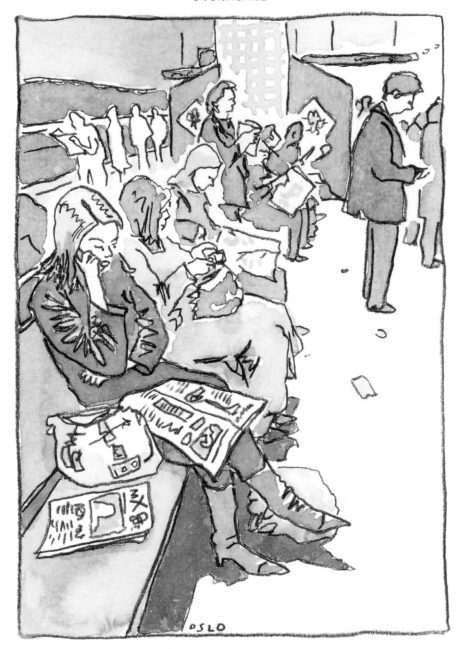

SUBWAY STATION, MONDAY 5:30PM

'I don't know if you'd call it irony, but Gaye *is actually gay*.'

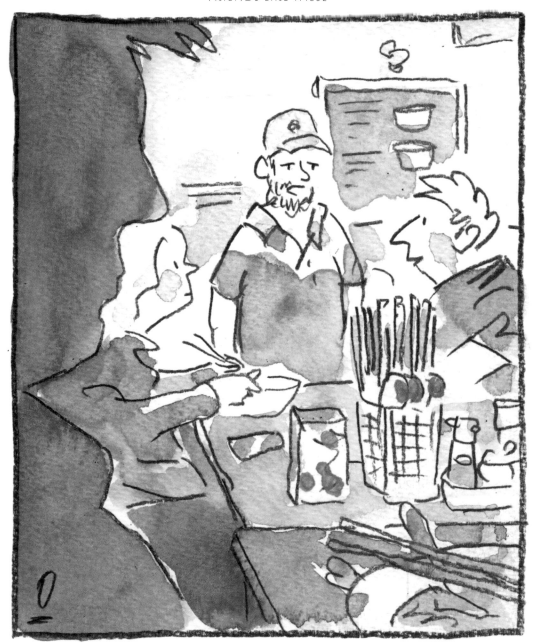

PHO SHOP, SATURDAY 6PM

Man One: 'I saw your ex recently. Is she like the angriest person in the world or what!?'
Man Two: 'What do you expect, she was with me for six years.'

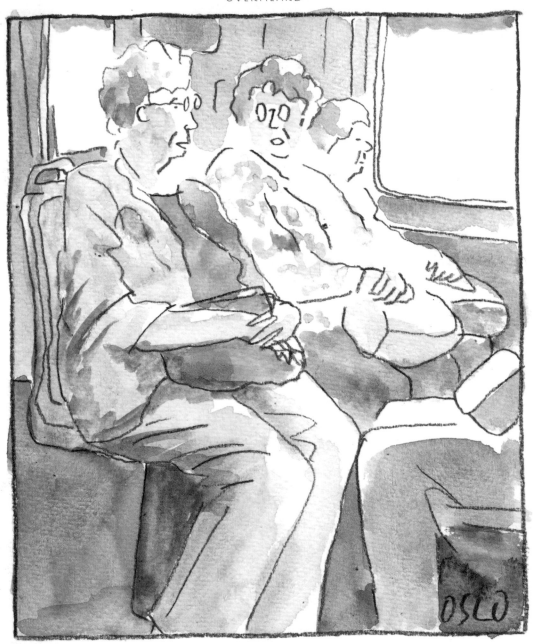

ON THE TRAIN, SATURDAY 10AM

Woman One: '*Ice Age Giants* finished last night. I now know all about the Siberian sabre-toothed tiger.'
Woman Two: 'Good. If I need to know anything about them I know who to turn to.'

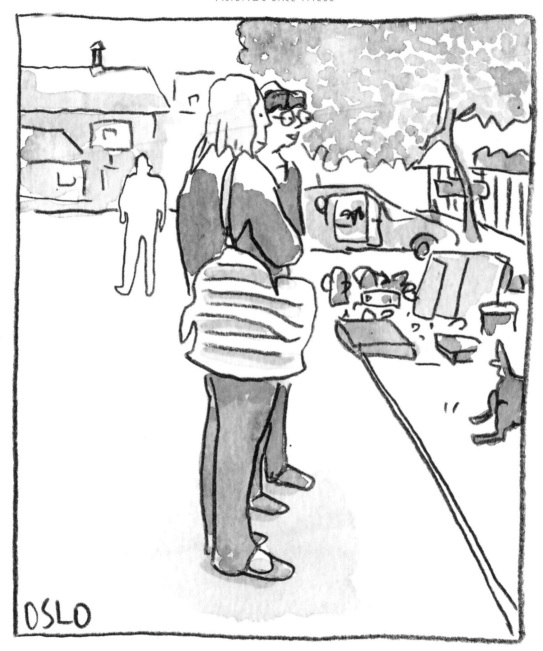

SUBURBAN PRIMARY SCHOOL, SATURDAY MIDDAY

'On my gravestone it'll say, "Had issues with his dog."'

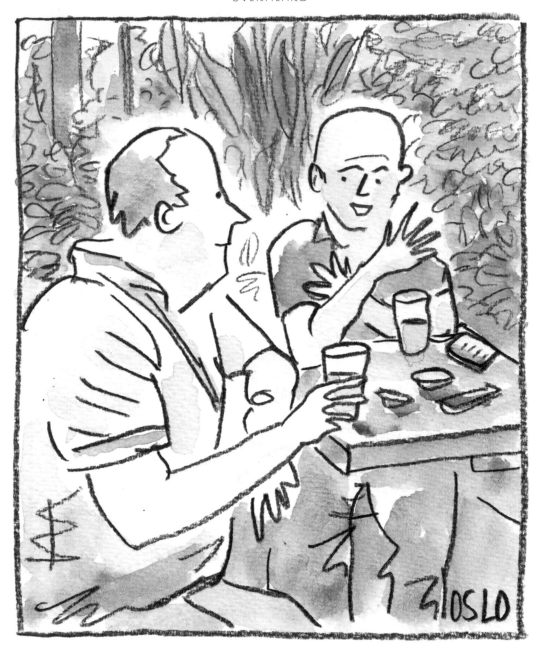

ROOFTOP BAR, FRIDAY 6PM

'What am I going to do with a full head of hair? Comb it?!'

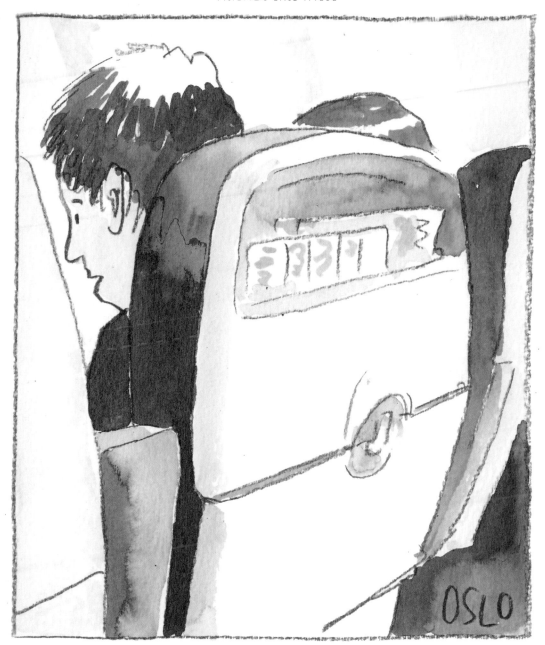

ON A PLANE, MONDAY 11AM

'They're playing Cat Power. What does it mean when I start liking the music they have on planes?'

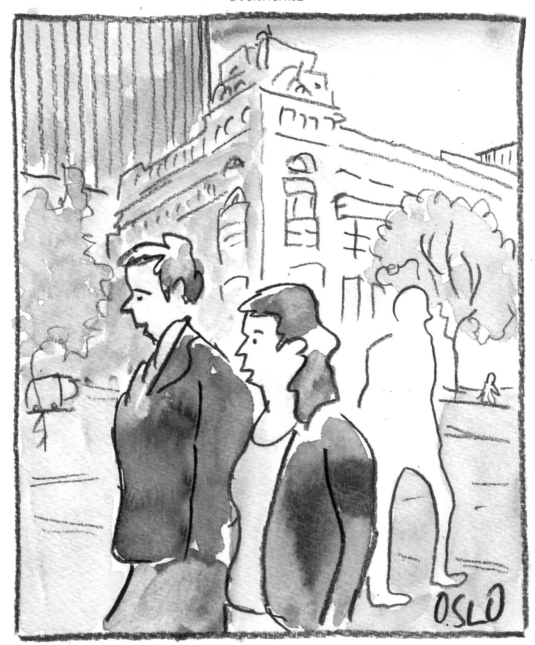

CITY STREET CORNER, FRIDAY 5:30PM

Him: 'The music they were playing was awful, so melancholy. All that moaning.'
Her: 'All our moaning!'

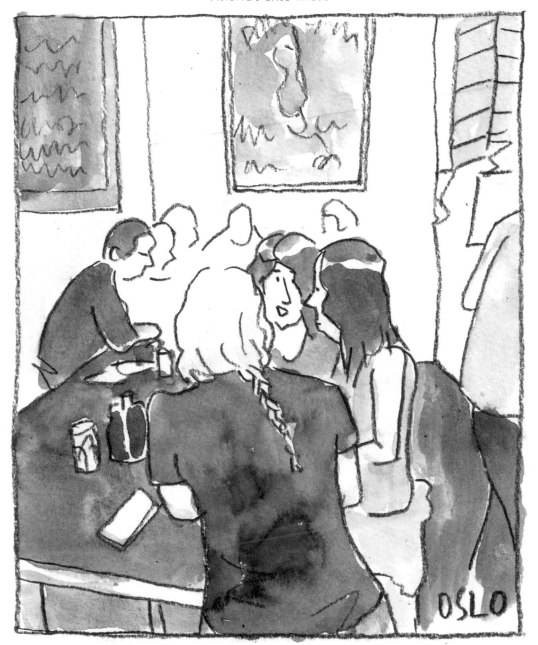

INNER-CITY CAFE, FRIDAY 12:30PM

'Seriously, Jen! Your stories are absolutely the only ones I can listen to!
They're hilarious! *(Pause)* Yours are of course funny too, Sam …'

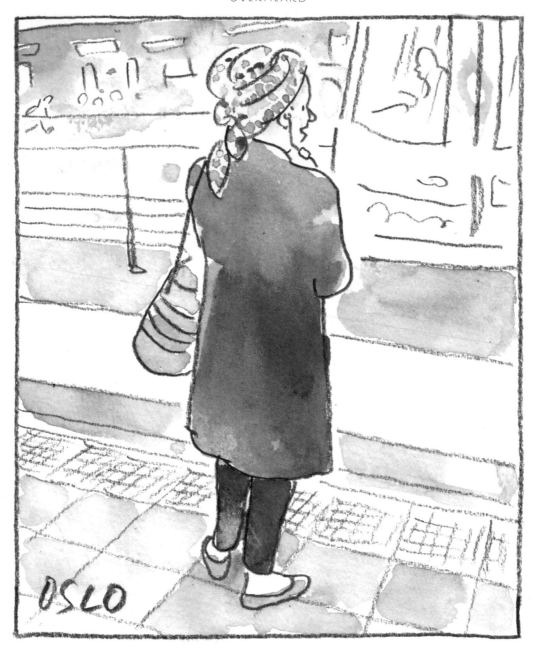

BUS STOP, SUNDAY 4:30PM

'Brad has two shots a day. Sometimes three. He'll go through a Grey Goose in two days.
I'm not taking it personally.'

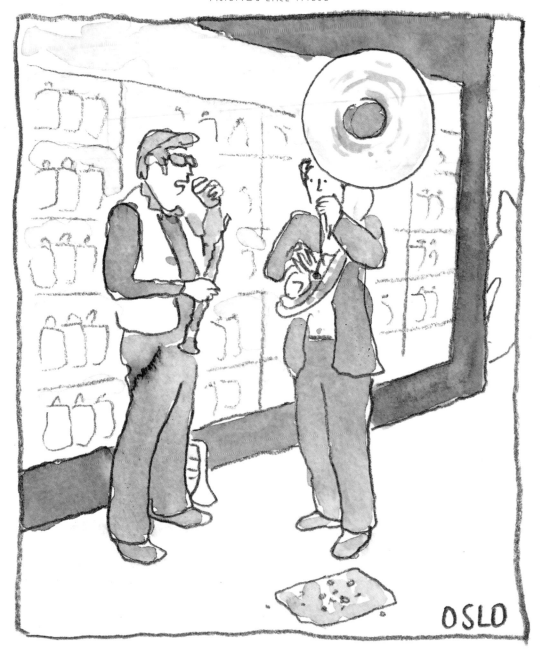

CITY LANEWAY, TUESDAY 3PM

'She's Buddhist, but she still kills bugs.'

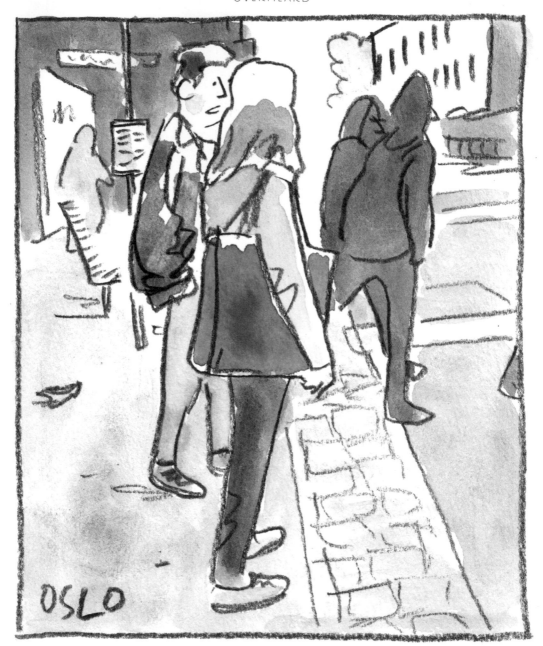

INNER CITY, WEDNESDAY 1PM

'Am totally cool with him hanging about all day on the couch, doing absolutely nothing. Not my problem. His life. Mind you, he does periodically steal from us.'

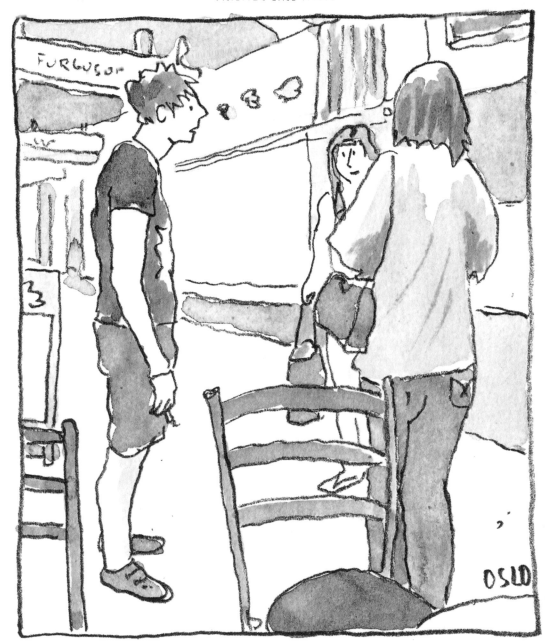

INNER-CITY SUBURB, THURSDAY 4PM

'I thought it was you who told me wasabi comes from wasabi peas, yeah?'

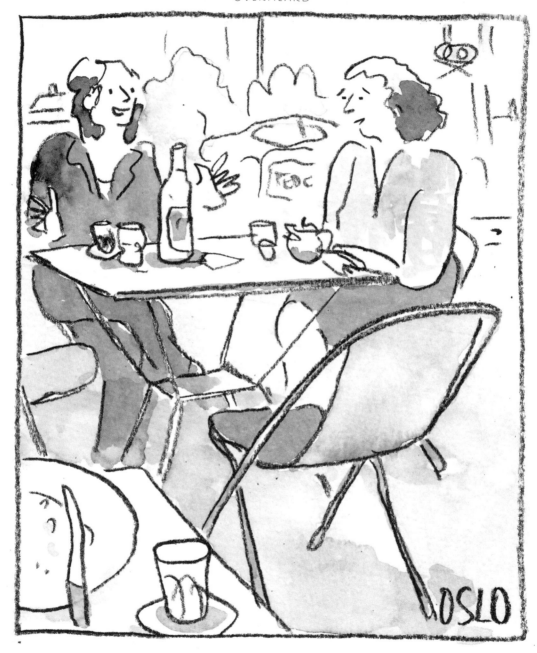

SUBURBAN CAFE, SATURDAY MIDDAY
'I saw a text pop up on my friend's phone at work that said "I GOT MY PERIOD!!"'

INNER CITY, FRIDAY 10AM
'I'm literally straddling her now.'

WHAT THE?!

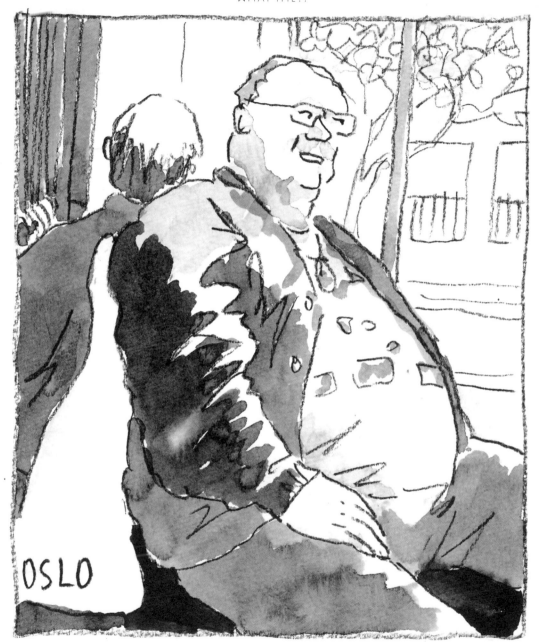

TRAVELLING, MONDAY 3PM

'I woke up and saw a rat sitting on its hind legs on the kitchen floor. Looking me up and down.
I went "BOO!" and it fell backwards. Dead. Had a heart attack.'

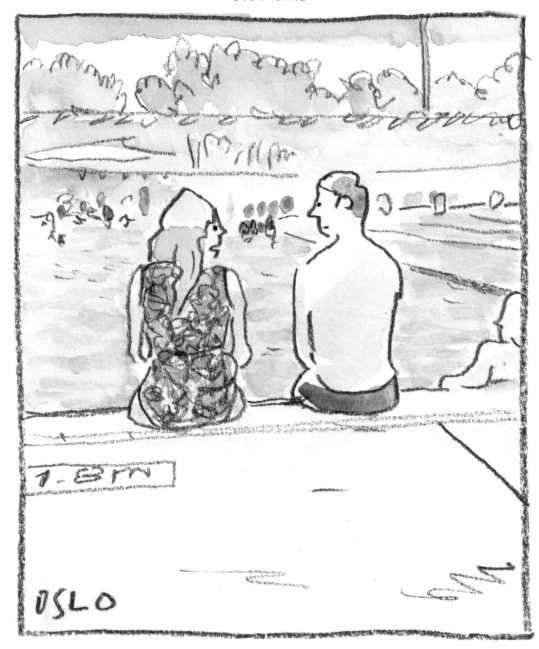

SWIMMING POOL, SUNDAY 2PM

'I've already witnessed your dad in tracksuit pants once.
I'm not sure I'm equipped to go through all that again.'

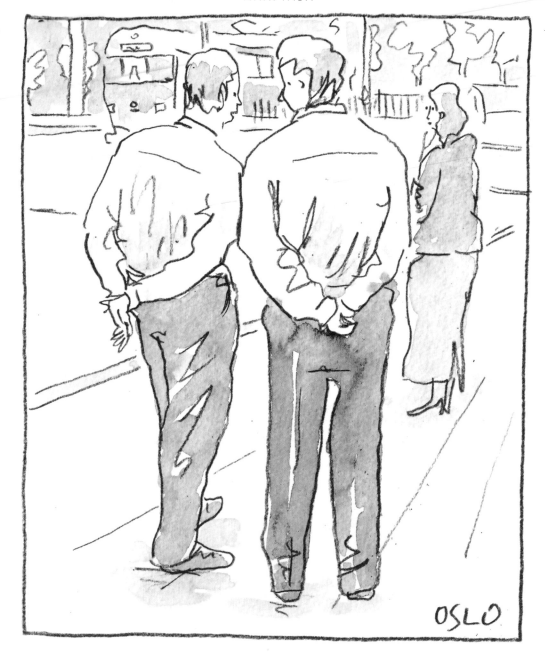

INNER-CITY SUBURB, TUESDAY 2PM

'They were a really good leprechaun provider.'

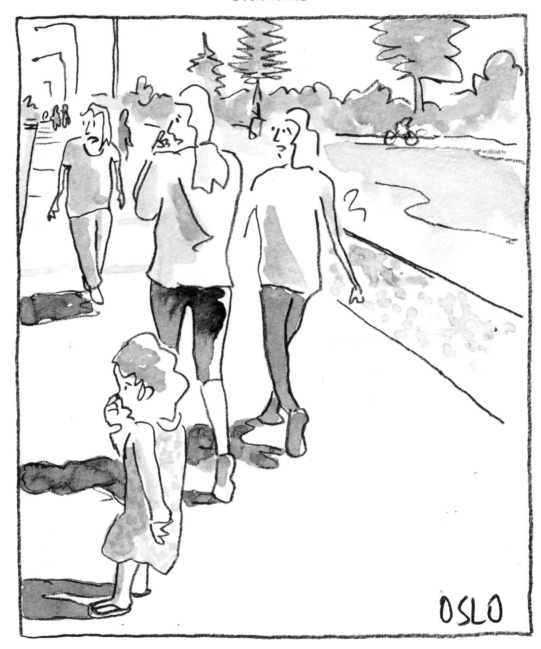

BEACH PROMENADE, SUNDAY 9AM

'And THAT'S why you don't feed dogs ice-cream!'

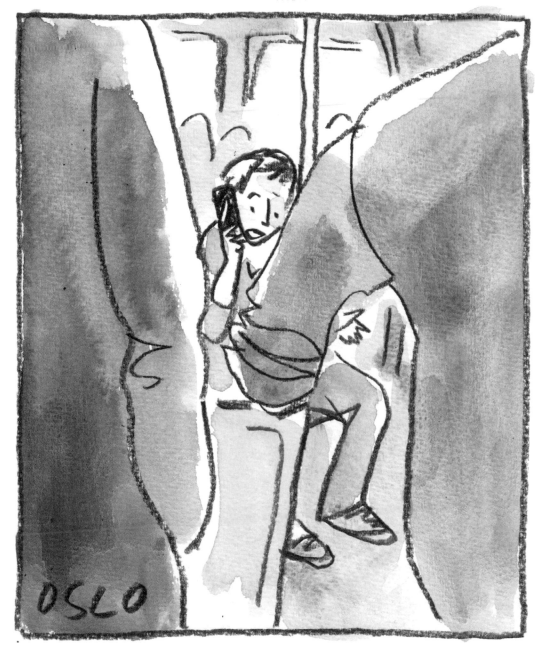

ON THE TRAIN, TUESDAY 4PM
'But Sam saw footprints! Walking in reverse!'

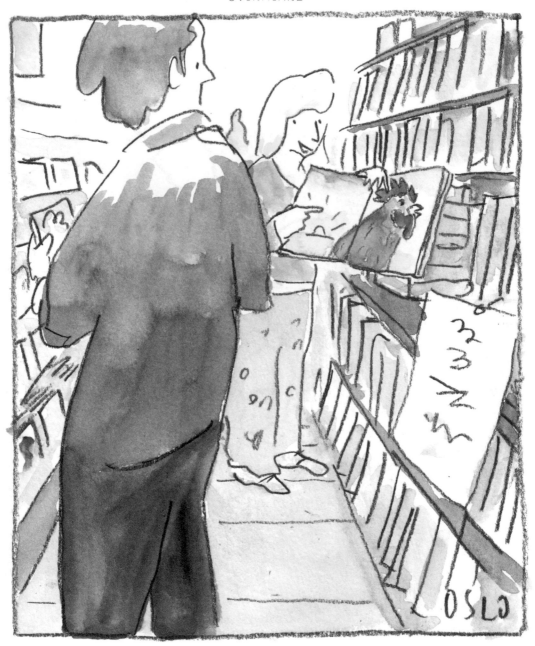

BOOKSHOP, MONDAY 9PM

'Hey, look – it's you.'

NEWSAGENT, SATURDAY 11AM

Him: 'You got herpes?!'
Her: 'Yeah, but only of the EYE!'

ON THE BUS, THURSDAY 5PM

'When we go away we put the dogs in a home, but one of them gets sick if he eats grass.
Like, violently sick. Don't suppose you want to look after him?'

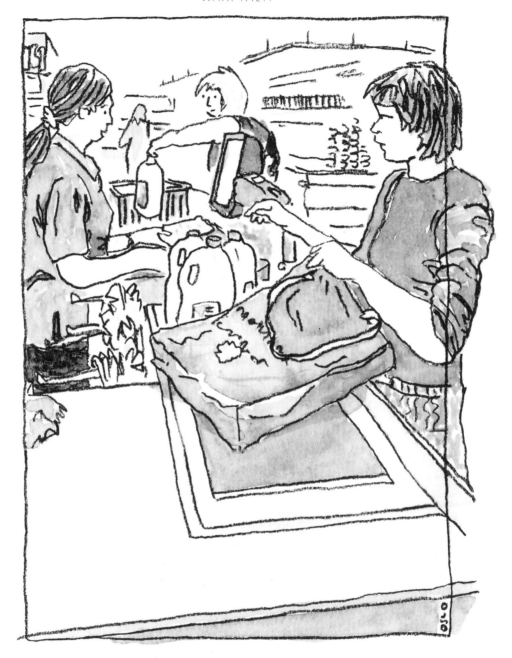

SUPERMARKET, SATURDAY 11AM

'Oh my – I thought these were Homer Simpson *tampons*!'

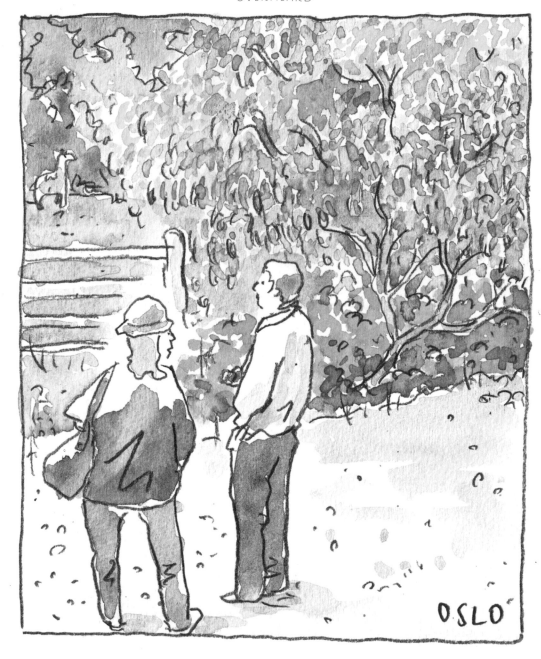

SUBURBAN BOTANICAL GARDEN, SUNDAY 11AM

'Hang on, that's not Nanna Ray. That's an alpaca.'

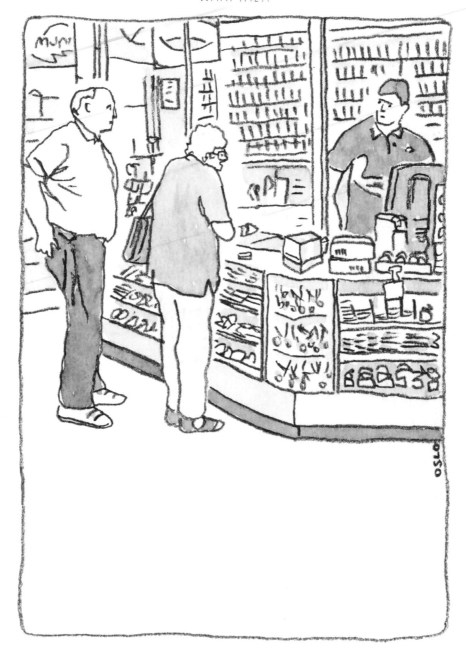

7-ELEVEN, MONDAY 9AM

'Just that, and 17 bags of ice.'

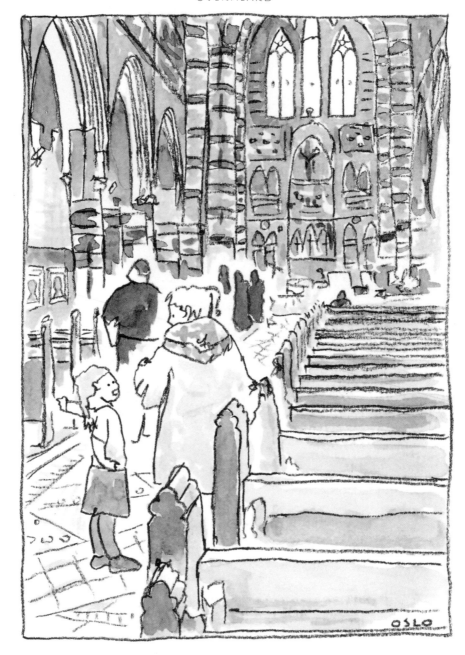

ANGLICAN CATHEDRAL, SUNDAY 3PM

'There's a picture of Frank Zappa.'

CITY LIBRARY, TUESDAY 2PM

'Michelle's husband is going to be there so I thought I'd tart myself up.
You never know what might happen.'

CITY, MONDAY 10AM

'There's still a lot I've got to get done, under the knife. But I'm still petrified,
'cause of my scars and stuff. You've seen 'em, you know what I mean, right?'

CITY MARKET, FRIDAY 10AM

Lady One: 'What you got there, dear? Boxing gloves?'
Lady Two: 'No, no – they're oven mitts!'

Published in 2017 by Hardie Grant Books,
an imprint of Hardie Grant Publishing

Hardie Grant Books (Melbourne)
Building 1, 658 Church Street
Richmond, Victoria 3121

Hardie Grant Books (London)
5th & 6th Floors
52–54 Southwark Street
London SE1 1UN

hardiegrantbooks.com

A Cataloguing-in-Publication entry is available from the catalogue
of the National Library of Australia at www.nla.gov.au

Overheard: The Art of Eavesdropping.
ISBN 978 1 74379 364 0

Publishing Director: Pam Brewster
Managing Editor: Marg Bowman
Project Editor: Anna Collett
Designer: Sinéad Murphy
Cover design: Oslo Davis & Sinéad Murphy
Production Manager: Todd Rechner
Production Coordinator: Rebecca Bryson

Colour reproduction by Splitting Image Colour Studio

Printed in China by 1010 Printing International Limited

All Overheards have previously appeared in the Sunday Age, some in a slightly different form.